Flowers in Watercolour

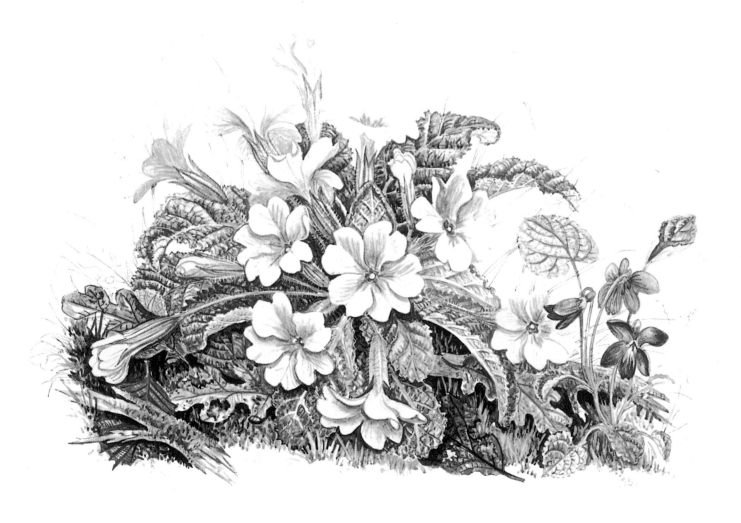

MARJORIE BLAMEY

To Philip, with love

First published in 1984
by William Collins Sons & Co Ltd
Reprinted 1985
New edition 1986, reprinted 1987, 1988 (twice),
1989, 1990 (twice)

Reprinted in 1991 by
HarperCollins*Publishers*
77-85 Fulham Palace Road
Hammersmith
London W6 8JB

The HarperCollins website address is
www.**fire**and**water**.com

Collins is a registered trademark of
HarperCollins Publishers Ltd

05 04 03 02 01
17 16 15 14 13 12

Edited by Jo Christian
Designed by Caroline Hill
Photography by Michael Petts

**A catalogue record for this book is available from
the British Library**

ISBN 0 00 413339 0

Printed and bound by Printing Express Ltd, Hong Kong.

CONTENTS

PORTRAIT OF AN ARTIST
MARJORIE BLAMEY

Marjorie Blamey was born in Sri Lanka and came home to England as a small child when her father returned to carry on his medical practice in the Isle of Wight. It was there that she found not only an interest in flowers, birds and especially in the butterflies which were so abundant on the chalk downlands, but also an ability to sketch them accurately and easily from a very early age.

At her first school she had to concentrate on the use of pencils as a medium and learned how shading could give depth and form to objects – a somewhat neglected form of art at the present time but one which she enjoyed then as much as she does now.

Her next school taught her nothing in the way of watercolour painting and little of the technique of oil painting, but allowed the privileged few who showed a flair, however small, for any of the arts to spend extra time dabbling in oils, ballet or acting. As she showed a certain amount of talent in all three, she dabbled to her heart's content. At the age of ten she won a Bronze Star at the Royal Drawing Society's Children's Exhibition for a study in oils; it was the first and last time she ever seriously painted the human figure. By the time she was twelve she had passed her full School Certificate in Art with honours. But her dabbling days were over. Her father retired early because of ill health,

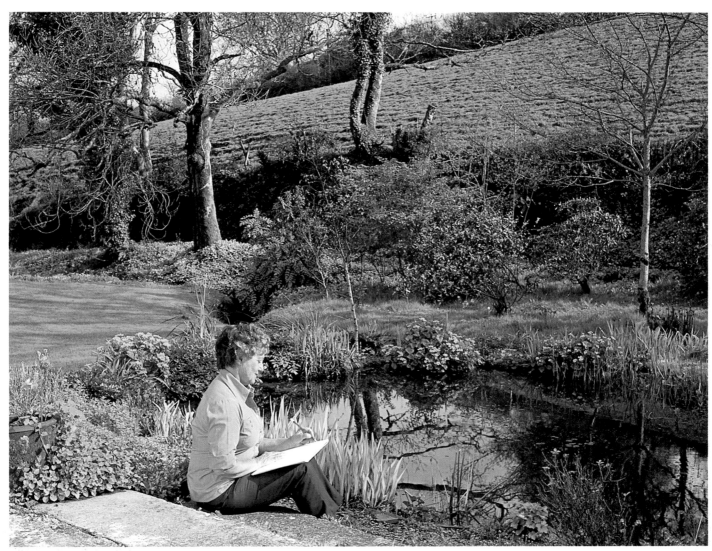

Fig. 1 The author, sketching beside the pond in her garden in Cornwall

and the family moved to surburban Surrey, where wild-life always seemed to be too far out of reach for her liking and school life consisted of a governess shared by a dozen girls, no art classes but one day off each week to attend an acting and dancing academy in London. She continued to sketch natural history subjects in watercolours in her own home, and at the age of sixteen she enrolled as a pupil for one evening a week at a local art class. As far as she can recall she survived for only three lessons before her teacher, surveying the highly detailed pencil drawing of a prickly conker which she was doing, bluntly told her that such an exact replica was not art, showed no imagination, was of little interest to anyone but herself and she might just as well throw away her paints and buy a camera with which she could snap her subject in 1/100th of a second, rather than waste hours of her time (and his too, he implied) trying to copy nature. She promptly took his advice and discovered a new art form and a lasting pleasure in black and white photography. She won many awards and one of her first was for a close-up portrait of a conker. She exhibited her work in London while still in her teens and her new-found semi-professional career as a photographer ran parallel with her main one as a budding actress on the London stage.

On the outbreak of war in 1939 she felt that neither career was particularly helpful to the situation and both could be shelved for the duration. She became a Red Cross nurse, and married a young army officer. After the war she and her husband, Philip, moved to his home county and bought their first farm in Cornwall. The theatre was forgotten, photography became a part-time hobby and any lingering desire she had to paint faded as the busy farm work, and the pleasure of living once more in the country with her own family, filled her days. Twenty-five years, two farms and four children later she picked the last bloom of a late-flowering clematis which was growing by the back door and shook the rain from its face, little knowing that she was holding a magic wand which was about to cast its spell upon her. All she felt at the time was a compulsion to paint it and she announced that she was going to take up watercolours again. It was the last word that surprised her now grown-up family, for they could not remember seeing her with a paintbrush during their lifetimes, except for the whitewash brush she wielded around the farm. Her first attempt at painting the clematis was, she says, disastrous, and she felt acutely disappointed at her inability to paint at all, let alone well. She knew she could have done it far better at the age of seven, and this failure spurred her into action. Painting only in the evenings, as farm work filled her daylight hours, she began to prove to herself that her art was not a lost one. Now, Marjorie is recognized as one of the leading

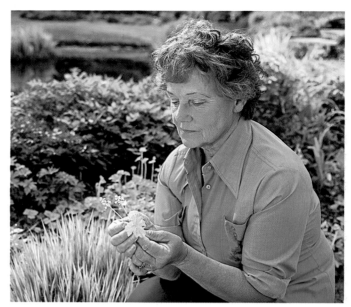

Fig. 2 Marjorie Blamey in her garden in Cornwall, examining a flower

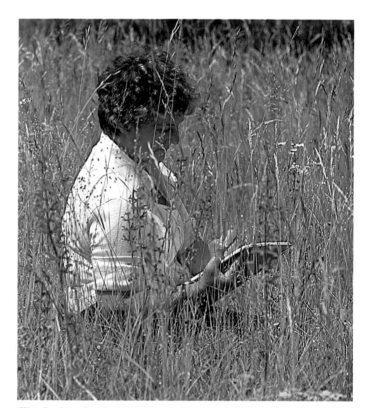

Fig. 3 In a field of flowers in France, during the filming of The World About Us

botanical illustrators. She has to her credit over thirty books, most of them published by HarperCollins. They include the best-selling *The Wild Flowers of Britain and Northern Europe*, now in eight languages, its companion volume, *The Alpine Flowers of Britain and Europe*, *Flowers of the Countryside*, *The Illustrated Flora of Britain and Northern Europe* and her latest book, *Mediterranean Wild Flowers*.

SELF-PORTRAIT

It is really to encourage everyone who would like to start painting again that I have drawn this portrait of myself, before we turn to flowers. Perhaps you have not painted since you left school and do not know how to begin? Maybe you feel nervous and unsure of yourself? If so, please read on, I will not only give you all the help and encouragement I can, stage by stage, but also, I hope, convey something of the enthusiasm and delight I feel when I am painting flowers. It is a very contagious feeling, so be prepared, you may easily catch it yourself.

To start with, I want you to remember that painting equals pleasure, and painting flowers in particular is pure pleasure. If by any chance you think you are too old to begin you can immediately forget such an idea, for by my very existence I am proof that it is never too late to start. From the very day we leave school most of us drop art and music out of our lives, only to regret it later on. We continue to expand our knowledge and our skills in many other subjects, but in art – no. A few go on to discover a lasting pleasure in painting as amateurs, or rewarding careers as professionals, but most of us step out of the world of art and do not know how to step in again.

I know how many of you will feel when you begin, because I have been through it all so comparatively recently. When first faced with a blank sheet of paper, a brush full of paint in my hand and no idea what to do with it or where to begin, I felt a rising panic, like stage-fright before a first performance. All those life-long artists who wield their brushes so easily and competently have long forgotten – or never had – those first-night nerves. It may be an absurd feeling but it is there for many of us, and prevents us from taking the initial plunge into art. All you have to remember is that it is merely a mirage, arising from the mystique which surrounds painting. Go back to childhood, play around with paint, get the feel of it again: splash it all over a sheet of brown paper if that is all you have at hand. Use a large brush or your fingers and watch the colours mix and run and clash together in varying shades. It is a lovely thing to do and when you have finished you can throw it away and start again. It is as easy and as painless as that. The mirage has vanished and you will find that you are enjoying every minute of your painting time, because you can but improve and that is what makes it all worthwhile. It is also one of the few occupations in which you can indulge that is therapeutic and pleasurable without ruining your purse; it won't annoy your neighbours, take up a lot of room, pollute the atmosphere, destroy mankind, wildlife or the countryside. You will be entering an absorbing new world which you will see with fresh eyes, and if your family complain that you are spending too much time in it, get them to read this book as well and you can all paint flowers and so turn your home life as well as your holidays into new adventures.

Have I fired you with enough enthusiasm to start? Or do you still need help and encouragement? If so, let us add the final touches to this portrait.

After my first childish attempt to paint the clematis, the flower studies which followed showed an advance in proficiency from a seven-year-old's to that of one of about eight, which was not exactly the rapid rate of growth I had expected or hoped for. At times I almost despaired of finding that gift which I had carelessly thrown away all those years ago, but I was haunted by

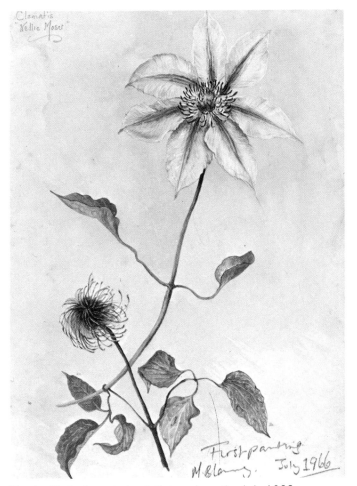

Fig. 4 First attempt at painting a clematis, July 1966

the ghost of the child I used to be, who painted easily and effortlessly, and luckily the memory made me carry on. In theory I knew that watercolour rather than oil paint was the medium I wanted to use for flowers, but in practice I discovered that I was completely ignorant about how to apply it, and I lacked the courage to enrol again at evening classes for tuition. A case of once bitten, perhaps. I felt that delicate, transparent flower petals with all their tiny and intricate markings called for delicate and transparent washes of watercolour. The only problem was that I stood between those paints and the paper and could not produce the effects I so desired; but from the moment in my new painting life – my second childhood in middle age – when I suddenly decided to stop feeling guilty about this desire to paint exact, detailed and realistic portraits of flowers, I felt an immense sense of relief. I had banished for ever another ghost, that of my last art teacher, who had constantly hovered over my shoulder telling me what not to do. I could now paint my flower portraits to my heart's content and as *I* wanted to, with every hair in place and every spot and line showing on their faces. His warning that no one would consider such a photographic style of painting as art bothered me not one bit and I was free at last to enjoy myself. I think my greatest step forward after that came when I abandoned my daughter's old school paintbox with its gritty paints and the worn-out brushes which, having spent their many idle years stuffed uncared-for into the box, had emerged from their ordeal in various stages of distortion, not one with a nice rounded form tapering to a fine point.

With an outward show of confidence in my future prowess which belied my inner doubts, I bought Artists' quality materials, no less, uncertain when I left the shop if I was suffering from over-confidence or merely showing off. They looked too good to use. I was, however, quickly to discover the sheer pleasure of working with sable brushes which behaved like trained ballet dancers, gliding smoothly on their points over a paper stage and springing back into shape after pressure was applied, instead of sinking into a feeble curt-

sey surrounded by a tutu of lifeless hairs. For far too long I had been using the cheapest see-through sketching paper, and faced now with new, opaque, smooth paper as thick as a magnolia's petal I could only think of my audacity at buying such material of the gods. It was with a feeling of awe that I applied that first brushful of new clear-tinted paint which had no grit in it and found that it flowed and smoothed out like silk and that the paper did not wilt at the sight of a drop of water. I cannot stress too strongly how important it is to buy a few good materials at the outset. One sable brush is better than a handful of very cheap ones. In my case I really could blame my inadequate tools to some extent for my initial poor results.

By now I was becoming really absorbed in painting and viewed my slow, steady advance with a great deal of detached interest. It was like re-living part of my childhood in a speeded-up replay of my life. The fact that I chose to paint garden flowers to begin with was merely a happy accident – or clematis magic, perhaps. Flowers interested me more than still life or portraiture and were always conveniently at hand to pick when farm work finished for the day, but I regarded them as stepping stones leading to the wildlife subjects I thought I would eventually like to paint when I could find the time to sketch outdoors. Little did I realize what an important role they were to play in the future. Strangely enough, I did not think of painting *wild* flowers at all. I much enjoyed seeing them on our farm where they were allowed to grow as they pleased along the hedgerows and in the permanent pastures, but I usually had my eyes focused on the sky watching for birds, and if I looked closely at the flowers it was more probably because there was a butterfly among them than for their own sake.

My plan at that time was to record in paint the flowers from our garden. Working from actual specimens in the hand and not from photographs or from memory, I would learn as much as possible about the technique of applying paint, how to mix colours and the best way of making the flowers look alive and shapely. A small and pleasant hobby – or so I thought

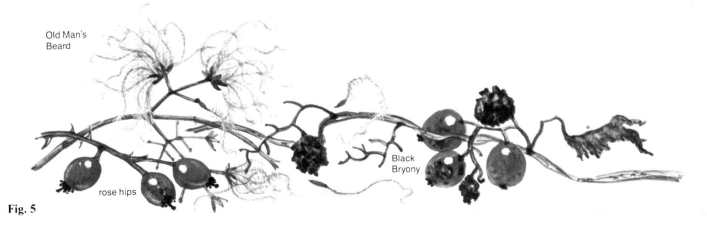

Old Man's Beard

rose hips

Black Bryony

Fig. 5

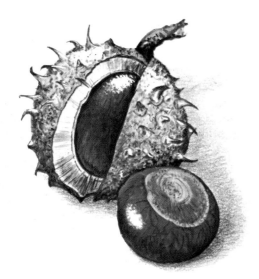

Fig. 6 Horse Chestnut conker

it would be at the time. When the last of the flowers disappeared for the winter I would pack away my paints and start again in the spring if I still wanted to.

After a few more weeks of steady work my flower studies were seen by several people who showed an interest in them. One of them actually bought a painting, which astonished me, and the word soon spread that something other than Cornish cream was being produced in our farmhouse kitchen. After that I was kindly but firmly pushed, still protesting that I was a farmer and not an artist, over the threshold of a new world and into an unplanned career.

I was invited to show a collection of my paintings at the County Flower Show the following spring and so my brushes were not packed away for the winter after all, and I found an unexpected pleasure in sketching branches covered in lichen instead of leaves, in painting the bare ruby-red stems of dogwood from the garden, and at last I discovered the wild plants of winter in the hedgerows outside the garden, rose hips and Old Man's Beard and cascading necklaces of Black Bryony, all brown and twisted, threaded with their orange and scarlet beads. I found a conker again and an even greater pleasure in painting it now that there was no one to tell me that fine detail was unnecessary and accurate portrayal not true art. With that conker I completed my circle and was back at the place where I had stepped out of the art world over thirty years before. Now I stepped back into it with great pleasure, because I had at last discovered a passion for painting the natural world of plants that was all around me outside the garden gate. It was a world that was full only of dying leaves and wild berries, but I found them fascinating to paint. The wild flowers which would follow in the spring were still some months away, but when the first primroses came out those clear, clean and fragrant flowers set the pattern for the future.

We staged that first small exhibition of my paintings

with scant ceremony and in total ignorance of how to display them to their best advantage. They were not even mounted, let alone framed, and a small piece of sticky tape at each corner was their only means of support. By the end of the day most of the paintings had been sold, I had commissions for several more and a request for four illustrations for a book on garden flowers, and I returned home in a state of shock. My family considered the book would be a wonderful opportunity for me and encouraged me to accept. I considered it would be a nerve-racking ordeal for which I was not yet qualified, but I did accept and learned a great deal while I did those few paintings. For one thing I realized that much hard work and dedication lay ahead if I was ever to reach the standard I now set for myself, for another that I was still not sure whether or not I would prefer the whole thing to go away and leave me to my peaceful farm life.

During the following year the decision was made. I received more and more commissions for work, until it seemed that painting was threatening to take over entirely. We both suddenly decided we were totally wrong to look upon this new adventure as a threat. Philip remained far more confident than I was that the demand for my work from private buyers and from nature conservation societies would continue to grow, but when a letter from the publishers Collins arrived asking me if I would like to illustrate a series of books on flowers for them, I had to believe him.

We determined to take the daring step out of farming and into this new, exciting life which was beginning to hold out so much to interest and occupy us both. We stepped from our hill-top farm into a house that we had built for us in the valley below and somehow found time to create there the garden we had always wanted around the winding stream with its natural waterfalls and its new pond. It is a garden which is now full of the cultivated and the wild flowers that I have illustrated in my books and is often seen on television programmes, including one in The World About Us series which featured our new life and travels among the wild flowers of Britain and Europe. Philip took over the business side of our joint venture, mastered the craft of mounting and framing my pictures and became deeply involved in matters of nature conservation. I was free to paint all day, and in order to deal with the increasing demand for my work I continued with my farm-life habit of starting at five every morning. The early hours of the day, like the early months of the year, are the favourite times of my life.

Wild flowers had now become more important and interesting to me as a painter than their more flamboyant garden relatives, but to sketch them for my own pleasure was one thing. When Collins asked me to illustrate them for a new comprehensive field guide, that was quite another. I suddenly found I knew woe-

fully little about the 1,800 flowers of Britain and northern Europe that I was to illustrate, and so another absorbing interest was added to our lives as Philip and I began to study them in earnest.

In order to enable me to paint all the flowers in the allotted time of two years – but often working a hundred hours a week – the publishers arranged for specimens of each to be sent to me by a team of collectors ranging from professionals in the many botanical gardens throughout Europe to a keen amateur on a remote Scottish island. Flowers which in Britain were too rare to be picked were sent to us from abroad where they were more plentiful. Occasionally we were allowed time to visit their secret hideouts and sketch them while they were growing, but our expeditions were few and far between for the work involved in painting the flowers within the scheduled span was considerable and left little time to spare for travel. But the first time we saw Military Orchids and Red Helleborines, which are so rare in Britain, growing like weeds along the roadsides in France was unforgettable, and set the pattern for our future travels in search of flowers to paint, for books and for the sheer pleasure of sketching them while they were still growing.

During the making of this first field guide to wild flowers we evolved an efficient system of filing the specimens for future reference. Each one was drawn on a large card and every detail concerning its habit of growth, size, colour, location, and so on, was also recorded on the card. After I had painted it for the

book the actual specimen, if it had survived the ordeal, was added to the card, pressed under clear adhesive film. In this way I have all the relevant details I require to paint the flower again at any time of the year, which eliminates the necessity of having to pick yet another specimen from our diminishing supply of wild plants. And so *The Wild Flowers of Britain and Northern Europe* was published in 1974. It quickly became the best-selling standard field guide and it is now available in eight languages. By the time it appeared we were already working on the companion volume, *The Alpine Flowers of Britain and Europe*, and this time we were able to travel in our motorized caravan to paint many of the flowers in the mountains of Europe, which was a most enjoyable way of going to work.

It is now seventeen years since I started to paint all over again and there are twenty-seven books on my shelf which I have illustrated and several more in the planning stage to occupy us for the next ten years. I somehow still find time to paint all those other wildlife subjects I love for my exhibition pictures and for the many organizations who promote nature conservation throughout the world. I also find time to paint purely for pleasure, and this usually means flowers and still more flowers. Iris Murdoch once wrote, 'People from another planet without flowers would think we must be mad with joy the whole time to have such things about us.' I find such madness a very pleasant state of mind. Why not join me and discover some of these joys for yourself?

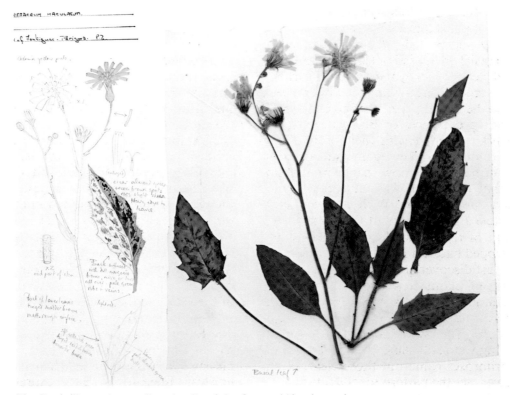

Fig. 7 A file card recording details of the Spotted Hawkweed

WHY PAINT FLOWERS?

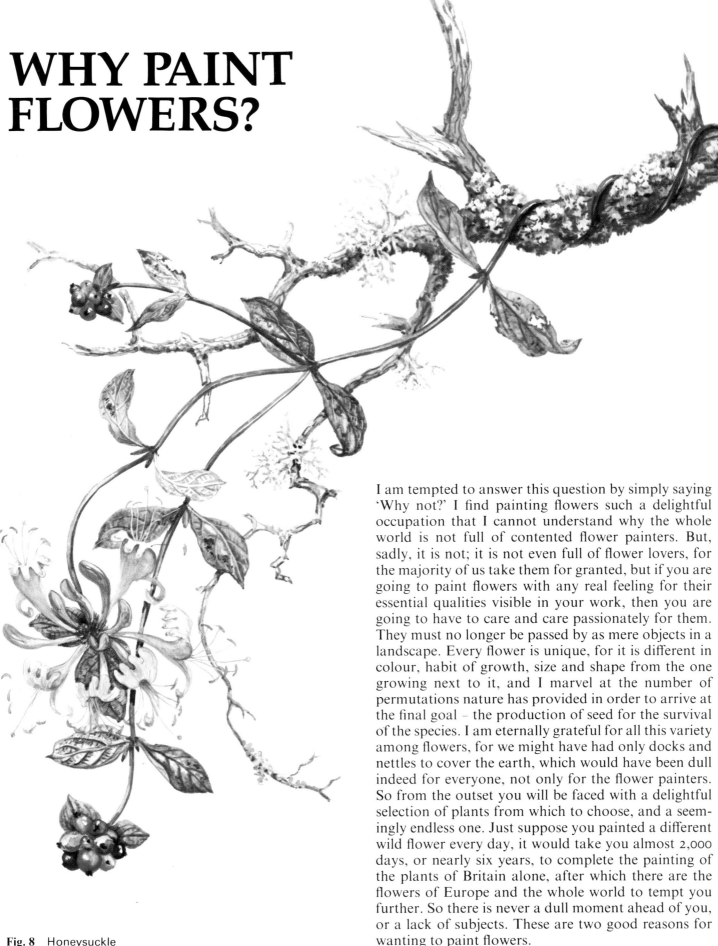

I am tempted to answer this question by simply saying 'Why not?' I find painting flowers such a delightful occupation that I cannot understand why the whole world is not full of contented flower painters. But, sadly, it is not; it is not even full of flower lovers, for the majority of us take them for granted, but if you are going to paint flowers with any real feeling for their essential qualities visible in your work, then you are going to have to care and care passionately for them. They must no longer be passed by as mere objects in a landscape. Every flower is unique, for it is different in colour, habit of growth, size and shape from the one growing next to it, and I marvel at the number of permutations nature has provided in order to arrive at the final goal – the production of seed for the survival of the species. I am eternally grateful for all this variety among flowers, for we might have had only docks and nettles to cover the earth, which would have been dull indeed for everyone, not only for the flower painters. So from the outset you will be faced with a delightful selection of plants from which to choose, and a seemingly endless one. Just suppose you painted a different wild flower every day, it would take you almost 2,000 days, or nearly six years, to complete the painting of the plants of Britain alone, after which there are the flowers of Europe and the whole world to tempt you further. So there is never a dull moment ahead of you, or a lack of subjects. These are two good reasons for wanting to paint flowers.

Fig. 8 Honeysuckle

If the prospect of all this superabundance of blooms is too daunting to contemplate, then make your own small world of flowers within the confines of your garden, the nearest park or the countryside around. You will derive much pleasure from painting either a few selected plants or the complete collection of all your cultivated flowers as they bloom throughout the year, thus making an illustrated diary of your garden, which would be far more fascinating than merely writing one. This is a project I am always hoping I can find time to do in my own garden, not only for the pleasure it would give to me but also because garden flowers, as well as wild ones, are lost over the years, and paintings of old varieties of pinks, primulas or roses, for instance, could become a valuable record of lost beauties – and yet another reason for painting flowers.

Some people may ask why go through all the lengthy process involved in order to paint one plant when twenty or more could be photographed in a fraction of the time. Painting and photography should not be compared with one another, they are totally different forms of art, each rewarding in its own right. I use a camera a great deal as an aid to my work; however, as a means of recording flowers I do find that photography has certain limitations, which are discussed in more detail on page 63.

I should now like to turn from why to paint flowers to how to paint them, the main concern of this book. I want to stress that I am going to concentrate only on the natural and realistic interpretation of living plants. I would strongly encourage any prospective flower painter always if possible to paint directly from living specimens or from his own field sketches. As I have already mentioned, photographs and pressed flowers are both important parts of my equipment as an illustrator of flowers. However, I use them purely for reference and always prefer to paint from the living plant. Fanciful and abstract flowers have their own place in art and commerce, for though we may ignore and destroy flowers in real life we still seem to demand a plethora of painted posies, good, bad, indifferent and sometimes downright vulgar, to adorn our clothes, china, wallpaper and curtains, our pictures, kitchenware and gift cards. But I think it is necessary at the outset to learn to paint flowers as they really are, before branching out into the many other ways of interpreting them in paint. Once you have learned a few basic facts about the structure of flowers and how to paint them, then you should be encouraged to develop your own style and to experiment. You can paint either the vibrant natural colour of a flower, or a mere suggestion of the shade; depict flowers in a faint wash of colour within a landscape, or as detailed plant portraits. Do not let anyone tell you that any particular way of painting is the 'right' way, but feel free to express yourself and flowers as you want to.

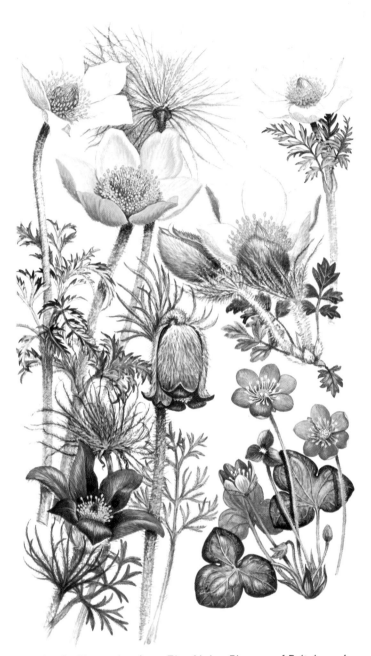

Fig. 9 An illustration from *The Alpine Flowers of Britain and Europe* by Christopher Grey-Wilson and Marjorie Blamey, published by Collins

A mixture of media

There are many interesting ways of colouring either pencil or pen and ink sketches, whether the sketches are to be works of art in their own right or merely a means to an end and a quick method of conveying the colour of a plant when working outdoors. A working sketch made with pencil, ballpoint or felt-tipped waterproof pen can be finished at home with a watercolour wash over the top. If I know I am not going to have the time to complete a painting of a particular flower, I sometimes take water-soluble pencils with me to indicate the colour here and there, make a few notes and on my return use a wet brush to melt the crayon into a wash of colour, to remind me of the correct shade when I make my final painting.

I particularly like using designers' markers for really rapid free-style sketches and for colouring pencil drawings. These pens are made in fine line or with thick, wedge-shaped ends. They are lovely to work with and are available in many colours; I especially like the cool greys for flower outlines and shadows.

You can get some interesting effects if you add pencilled grasses, leaves and other natural bits and pieces to a finished flower painting. I used this idea when I first started – or re-started – to paint, often because I hadn't the time to finish a picture. I liked the effect and developed it from then on and used it extensively in our book *Flowers of the Countryside*. Some pencil sketching is included in the illustration in **fig. 64**.

If you prefer pen to pencil you can use a pen-holder with a fine mapping nib, or one of many wider types of nib which produce lines of varying thickness and are so versatile, or a technical drawing pen. A technical pen continues in an unbroken line for miles on one tankful of ink, but you will not be able to vary the width of the line unless you have several different sizes available. They are certainly useful outdoors, but I find the uniform outline frustrating, and when I am working at home I much prefer a flexible nib.

You can do your ink sketches first and colour-wash over them or the other way round, either way they are fun to do and interesting pictures can be achieved. Try different coloured inks. I particularly like peat brown, it is more sympathetic than black for sketches of woodlands, and so on. I also use green, but never neat, I prefer to mix it with Burnt Sienna to obtain a less brilliant shade. You can also dilute inks with water and apply them with a brush, but they stain and dry rapidly and cannot be manipulated like watercolours. Moreover, not all of them are fade-proof, so remember this when you discover that the Carmine is just the right colour for one of those difficult pink flowers, such as Bloody Cranesbill.

Finally, a quick look at pastels, which have a lovely misty quality unobtainable in any other medium. I wish I had the time to use them more extensively. At the moment I only add touches of pastel to lichen-covered branches or to the wings of a Chalkhill Blue butterfly in order to achieve that lovely powdery effect. They deserve more attention. If you are afraid of smudging your pastels spray them with a fixative.

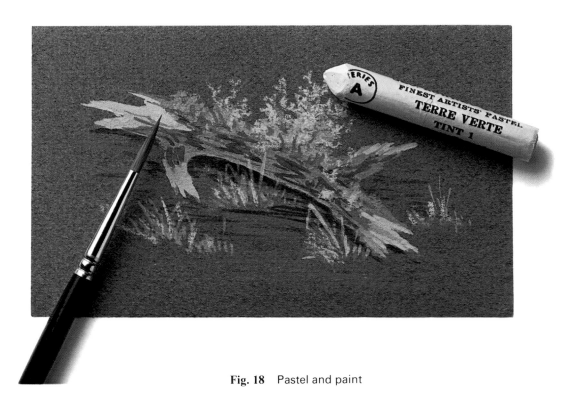

Fig. 18 Pastel and paint

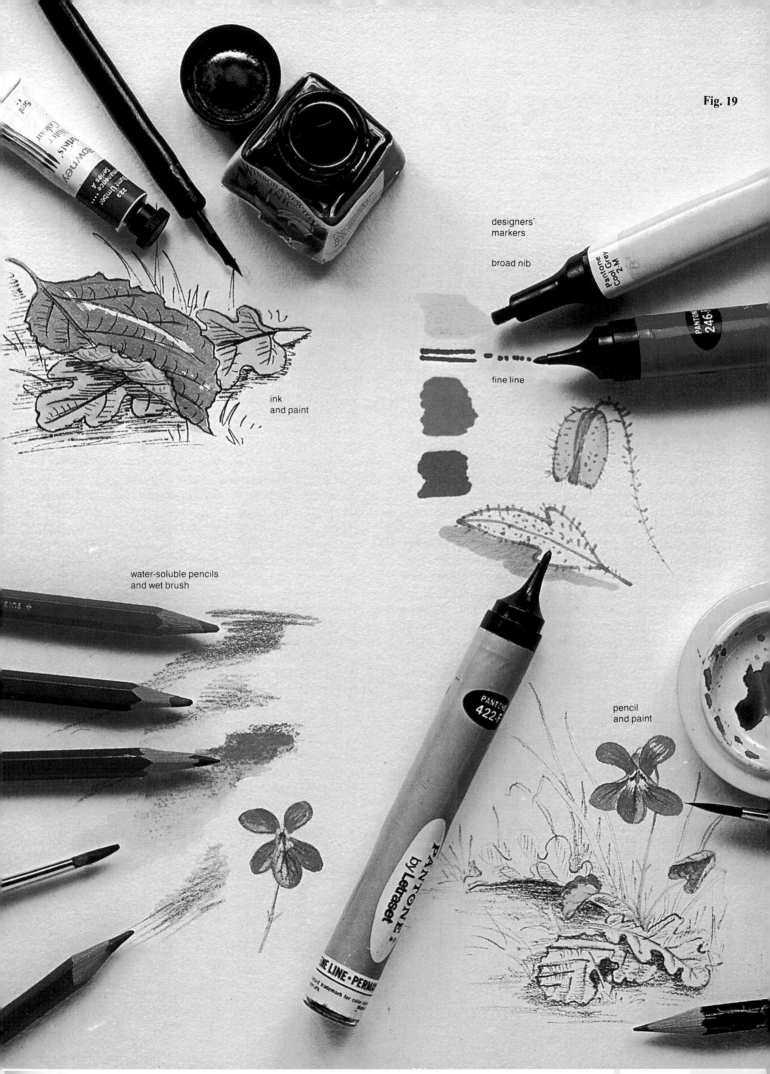

Fig. 19

designers'
markers

broad nib

fine line

ink
and paint

water-soluble pencils
and wet brush

pencil
and paint

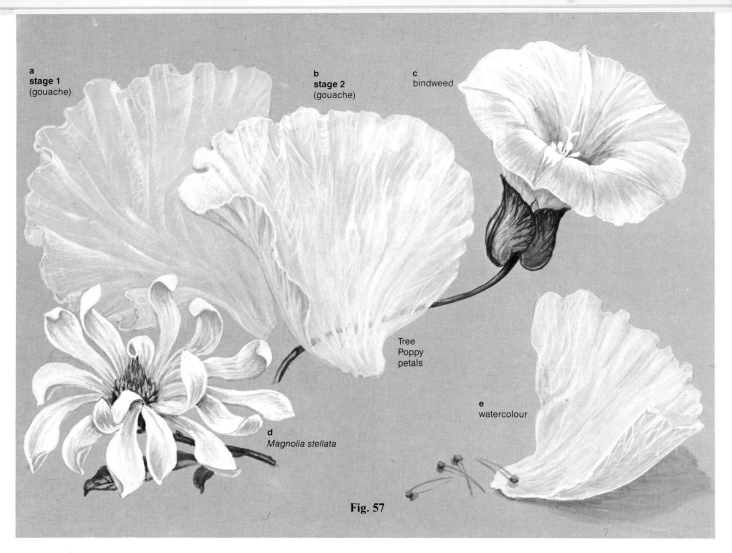

a
stage 1
(gouache)

b
stage 2
(gouache)

c
bindweed

Tree
Poppy
petals

d
Magnolia stellata

e
watercolour

Fig. 57

White flowers on tinted paper As I have already mentioned, gouache paints are particularly effective on tinted paper. However, if you have no gouache available, watercolours too are perfectly suitable for use on the paler papers. I used white gouache paint for the petals of the Californian Tree Poppies in **fig. 58**, but the rest of the painting, including the stamens, was done in watercolours. In **fig. 57e** I also used watercolour for one petal, in order to prove the point. The grey paper I used for the Tree Poppies painting is not specially made for the watercolourist. I found it at our local printers'; it is thick enough to take paint well and is in a cool, neutral shade of grey I wanted when I illustrated *The Wild Flowers of Britain and Northern Europe*. I used it for some of the pages of mainly white flowers in that book and have used it for a great deal of other work since then. It is a useful tone for this demonstration, for it is darker than the petals but paler than the shadows on stems and leaves. In **fig. 57** I began to paint my white poppy for you by lightly marking in the outline, using white paint here and there; if you prefer to use pencil, keep it very faint. When you become accustomed to the shape of the flower you can apply your first thin wash of colour all over the petals without bothering to do the outline, which gives you a lovely feeling of freedom and satisfaction. In **fig. 58** I only marked in the position of the stems. I like to vary the opacity of this first thin layer

of paint by adding more water here or extra paint there (**fig. 57a**) to get the effect of shadows and highlights and the extreme thinness of the petals of these beautiful flowers, which grow in our garden and look like ballet dancers in white tutus. If you like to leave one or two flowers half-painted you can get an attractive out-of-focus and distant look to them which greatly emphasizes the more detailed flowers in the foreground. This gives your painting depth and distance, the three-dimensional look which I like so much. After the first wash you can then add to the more opaque areas, where the petals overlap for instance (**fig. 57b**), but do not apply too much paint for these or for any other transparent flowers, such as bindweed (**fig. 57c**). A painting of bindweed on white paper is illustrated in **fig. 55**; you can now compare the two ways of depicting this same flower. You can also compare the painting of *Magnolia stellata* (**fig. 57d**) with the one on white paper in **fig. 55**. As with all the species of magnolia with petals which look and feel like soft white kid leather, more paint is required to get the 'feel' of the thicker, opaque petals. Allow white paint to dry and harden thoroughly before adding stamens to your Tree Poppies, or shadows to any thicker-petalled flowers.

The stems and leaves of the Tree Poppies in **fig. 58** have been painted in Terre Verte watercolour, with touches of yellow and of Payne's Grey in the shadows. White highlights help to round off the stems.

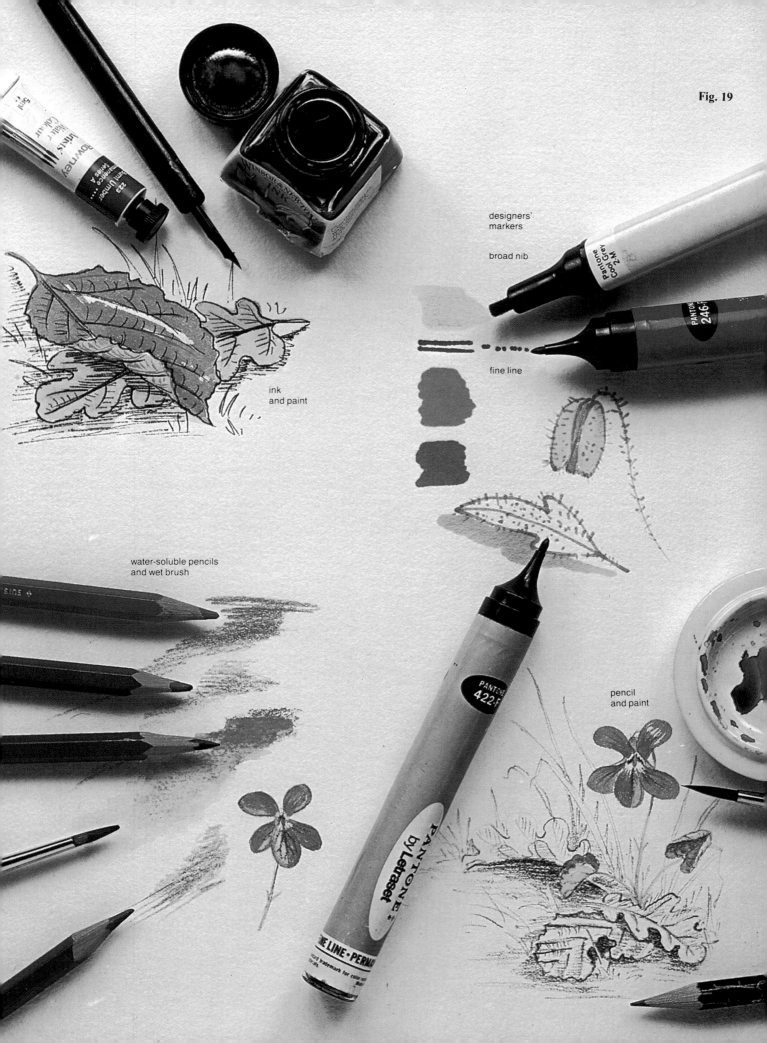

Fig. 19

designers' markers

broad nib

fine line

ink
and paint

water-soluble pencils
and wet brush

pencil
and paint

LET'S START DRAWING

Leaves

You may consider that the outlines I have drawn on these pages are too stiff and formal and are a boring way to start drawing plants. You would be right, of course, but for a short while we must take a clinical look, however brief, at a few basic facts. You cannot build a house successfully without first drawing your plans and becoming familiar with the general shape, or if you do you will probably get your angles wrong and then nothing will fit together. The same principle applies when you are building up a picture of a plant. So start by practising basic shapes. Your subsequent free-style drawings will be so much easier to do and your leaves will be in correct perspective with accurately placed lines, and not – as so often happens in paintings – suffering from dislocated joints and fractured midribs inflicted by the artist through lack of knowledge or through carelessness. These mistakes can be avoided if you learn to *look*. Stop rushing about, pause and really look at a flower, any flower, even a common daisy is beautiful if you examine it closely.

It is not really essential to study botany to become a good painter of wild flowers, but a little learning, in this case, is not a dangerous thing and the facts of plant life are so fascinating and intriguing that I hope you will not be able to resist buying a field guide to wild flowers – one of mine, I trust – which will help you identify individual species; a correctly named flower is far more interesting to paint than an unnamed 'weed'.

Look at the general shape of your plant, see how the leaves spread their flat surfaces, not their edges, to the sky and how they are arranged on the stem so that as many as possible can receive the maximum amount of the solar energy required to keep the plant growing well. In **fig. 20** below you will see how plants achieve this by various standard methods, each leaf placed where it will receive some light without shading the one below. Then look at the stem of your plant (see **fig. 22**). Is it curved or straight (though never draw it with a ruler, for it won't be as straight as that); is it round, triangular or square? This is the point at which you can, at long last, pick up your HB and draw sweeping strokes following the general line of your stem. Go on drawing them, all over the paper, not in short, hesitant dashes but with sweeping confidence, and you will get it right before long. Do not be tempted to add curves to a naturally straight stem just to pretty up your painting; it has been made like that for a specific purpose, to support a heavy flower perhaps, and the plant would fall flat on its face if it were designed in any other way. It is only when man demands bigger and ever bigger blooms for his garden that nature has to be given an artificial prop. I have also sketched some of the protective covers and weapons that surround the stems **(fig. 24)**, from bare, shiny skin to wicked-looking thorns, and the variety is endless; even the hairs can differ one from another, some thick and felted, others sparse and standing out at all angles. Thorns too can vary even within the same family: some roses, for instance, produce an impenetrable forest of thin, straight prickles at right angles to the stem and others have strong backward-facing hooks; but you will not find among them thorns which curve forward towards the flowering tip of the branch – although I have seen beginners make this mistake in their pictures – for they are swords which protect the plant from being devoured by grazing cattle and from small climbing creatures. (Though the defence is not always successful, for I have watched a field mouse shin up the stem, apparently unharmed, to sit in triumph at the top eating its bunch – or brunch? – of rose hips.)

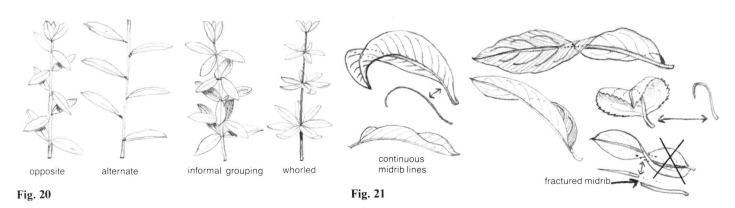

opposite alternate informal grouping whorled continuous midrib lines fractured midrib

Fig. 20 **Fig. 21**

Having drawn the general shape of your plant, noted its outer covering and the position and the angle of its leaves and how they join the stem, you must now look at the design of the leaf in detail **(fig. 23)** and try to think of it in skeleton form. The all-important central vein or midrib is the main artery and from it small veins radiate to the outer edges of the leaves, except in the leaves of the lily family, where the lines run parallel to the central vein. Collect leaves from as many different plants as you can, and pick up and press the ones that fall from tall trees in autumn, and I think you will be astonished to see the variations that occur in the shape, colour, thickness and even feel of them, to say nothing of the many decorative edgings, which vary from fine serrations which look as though they have been cut out with small pinking shears to the large, lobed indentations of the oaks, from the small fingers of maples to the huge hands of Horse Chestnuts. Draw your midrib first, again, as with the stem, in one continuous line **(fig. 21)**. This line must appear to be unbroken, even if you cannot see all of it and however much it may curve. It must never be fractured or dislocated anywhere along its length. The tip of the leaf may curl underneath but the line of the curve will always flow smoothly and gradually and never be acutely angled. After this you can add the smaller veins which radiate from the midrib, but carefully check their positions first of all. They are placed precisely opposite each other in some leaves, while in others they are arranged alternately. Sometimes there is even an informal mixture of both within a single leaf.

Practise looking right through your leaf to the far edge, as though it were made of glass. There is something very satisfying about drawing continuous flowing lines that all meet up in the right place.

Fig. 22

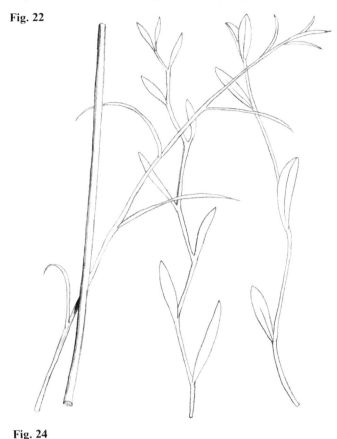

Fig. 24

Fig. 23

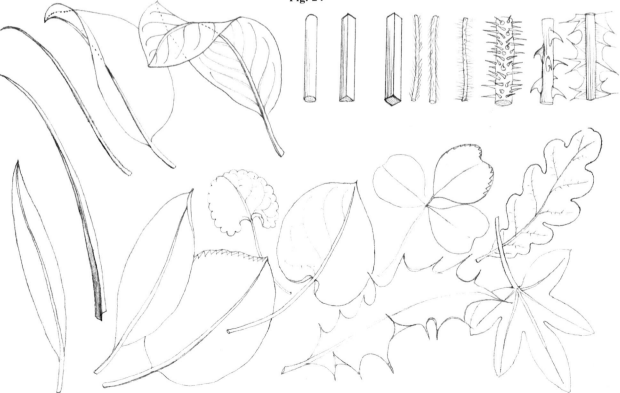

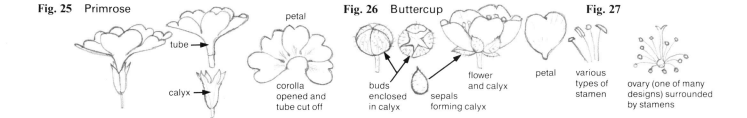

Fig. 25 Primrose

tube →
calyx →

petal

corolla
opened and
tube cut off

Fig. 26 Buttercup

buds
enclosed
in calyx

sepals
forming calyx

flower
and calyx

petal

various
types of
stamen

Fig. 27

ovary (one of many
designs) surrounded
by stamens

The construction of flowers

It is not going to be necessary for you to unpick the seams of all your flowers every time you wish to draw them, but, as in dressmaking, it helps occasionally to spread out the pattern, as I have done in **figs. 25 and 26**, check your measurements and see how best to achieve a perfect fit, particularly where the tube of a flower fits into its calyx like a sleeve into an armhole. I have already mentioned how many variations occur among leaves: these are as nothing when you come face to face with flowers. All those lovely shapes, those intricate markings, the way some look straight into the eye of the sun while others hang their heads in shade. Some plants produce only one flower to a stem, others a

hundred or more in great spikes, corymbs or racemes, umbels or panicles or any other splendid-sounding collective term for a superabundance of blossoms. The only problem is that the individual flowers face in all directions and you have got to get them right – for I take it for granted that you wish to draw flowers in a botanically accurate way. This does not necessarily imply that your finished sketch must contain every minute detail, unless you are working in an herbarium. If you prefer a freer style using only a minimum number of lines, *so long as they are in the right places* you can achieve excellent and recognizable impressions of a plant which may look more alive than a more intricate drawing; and the reduction of detail to a mere suggestion is fun to do.

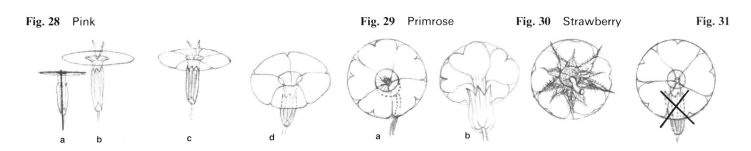

Fig. 28 Pink

a b c d

Fig. 29 Primrose

a b

Fig. 30 Strawberry

Fig. 31

Flowers in perspective

The little garden pink with its single flower divided neatly into five flat petals sits fair and round like a small plate on top of its long, column-shaped calyx and provides us with the perfect-shaped model with which to practise drawing flowers in the correct perspective. Hold it upright and draw the simple T shape it presents in profile (**fig. 28a**) and then gradually turn it towards you and draw a series of discs, with a hole in the centre of each one leading down through the throat and into the collar of the calyx underneath (**fig. 28b, c, d**). These oval shapes will gradually become a full circle and the calyx just as gradually disappear behind the flower. 'Think' your way through the flower as if it were glass, mark in the disappearing calyx with a series of dots until you are satisfied you know how to achieve this vanishing trick accurately and easily. Then try the same exercise with a primrose or a polyanthus, turning the

back towards you as well as the front – it is equally important to get the back right (**fig. 29**). Look closely at the calyx of any flower you draw. It might best be described as a suitcase into which the flower (and often the seed capsule) is packed. Sometimes the calyx is discarded as soon as the flower opens, but if it is still present note how the lobes or points come between the petals, which sounds simple and easy until you come up against a plant such as a strawberry, which has a normal calyx but also an epicalyx on top with its points up the *middle* of each petal (**fig. 30**). Some plants, such as daisies, have numerous petals and so many points or bracts on the calyx that things get somewhat disorderly, but again I stress *use your eyes*. It's all a question of looking and learning. Finally, please do not cause injury to your plant by drawing the flower full-face and the calyx in profile, thus dislocating its neck (**fig. 31**) – this has been done on many occasions, and it is a mistake which is so easily avoided.

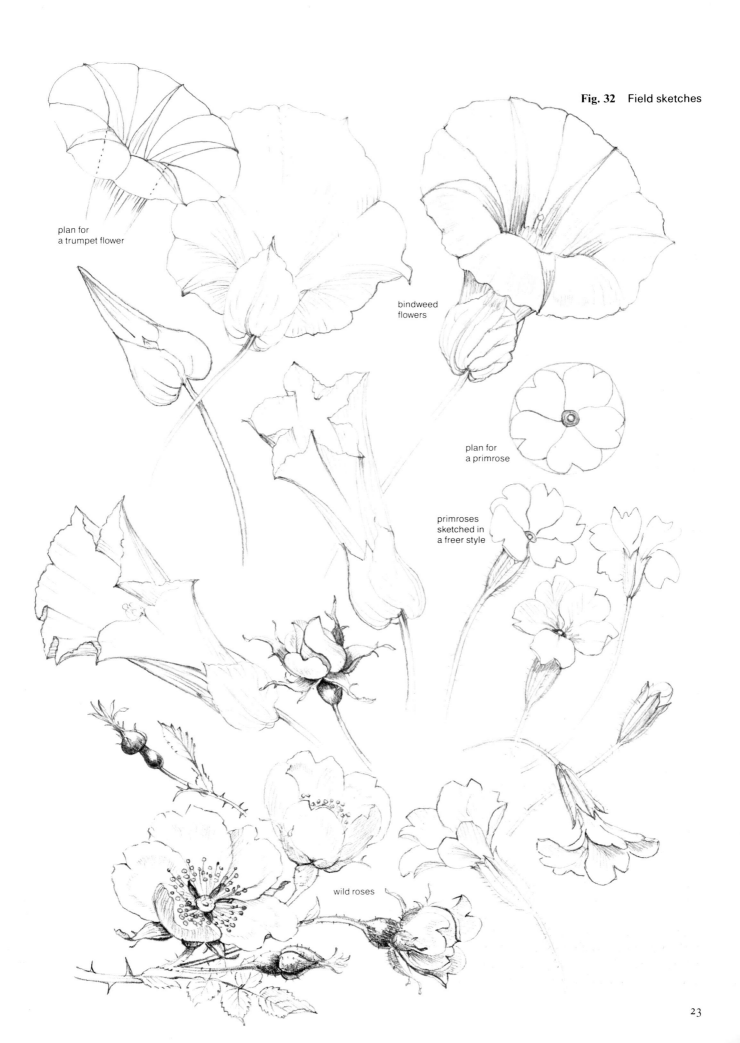

plan for
a trumpet flower

bindweed
flowers

Fig. 32 Field sketches

plan for
a primrose

primroses
sketched in
a freer style

wild roses

23

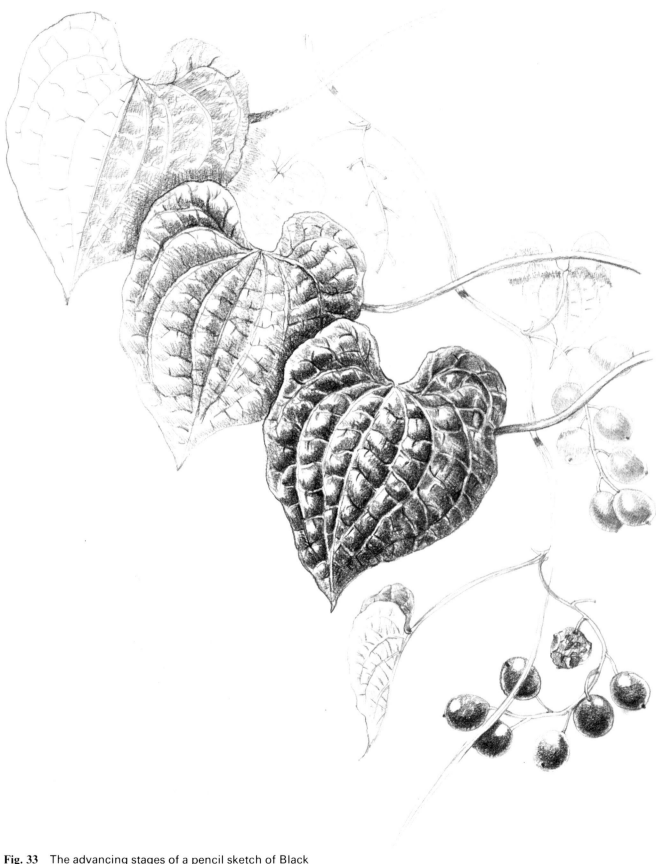

Fig. 33 The advancing stages of a pencil sketch of Black
Bryony leaves and berries, from outlines drawn
with H and HB pencils to finished details and
shading with 2B and 4B pencils

Sketching outdoors

I never go anywhere without a pencil and a sketch pad
if I can help it. Although my grandchildren like to have
all my worn-out brushes and off-cuts of paper they are
particularly avid collectors of my stubs of pencils (to
them anything under five inches is – hopefully – a stub),
but I still manage to hide the few they have overlooked
in various pockets and handbags and I always have
a supply in the caravan. What is more, I really do use
them, anywhere and everywhere. I long ago decided to
stop feeling self-conscious about sketching in public,
but this is not easy to achieve. Artists are usually secre-
tive creatures, preferring not to work with the curious
public looking over a shoulder, let alone the all-seeing
eye of a television camera, which hovered over mine,
only an inch from my face, purring into my ear as I
painted my way through the filming of our World
About Us programme. That camera cured me of shy-
ness in one shot. Forget your inhibitions and sketch
wherever you are. I find an HB pencil is the easiest and
quickest thing to use; a felt-tipped pen is excellent too
but does not always produce fine enough lines for small
details. I use a sketch pad with a hard back to it. People
in Cornwall are used to seeing me sketching flowers in
gardens on Open Days, and their owners give me speci-
mens to take home to paint at leisure. I am often
overwhelmed with their generosity, especially on one
occasion when I needed a particular magnolia for a
book. I wrote to ask the owner of a large estate for
permission to pick one small bud and was met by the
head gardener, who proceeded to saw off several
branches not only from the one tree I wanted but from
any others that caught my eye. Covered with pink
blossoms and confusion, I walked through the crowds
of sightseers, who I am certain thought I had violated
the 'Do Not Pick' law which everyone longs to break
in such a garden.

Having found, begged or borrowed your flower, you
must decide how you are going to draw it. A quick
sketch with shading like the one of bryony shown here
(**fig. 33**)? Or a more formal botanical study like the
drawing of the orchid (**fig. 34**)? When you are shading,
use the side of the pencil and keep it as flat as possible.
If you intend to paint your flower then the drawing is
just a means to an end and must be done very lightly,
using an HB, as few lines as possible and no shading.
You cannot rub out pencil marks which have been
painted over, and a pale-coloured petal does not look
good with a hard pencilled outline. Too much pains-
taking drawing often spoils the natural flow and line
of the following painting.

Fig. 34 (*right*) A detailed botanical study of the Common
Spotted Orchid, the outlines drawn with F and HB pencils, the
shading done with 2B pencil

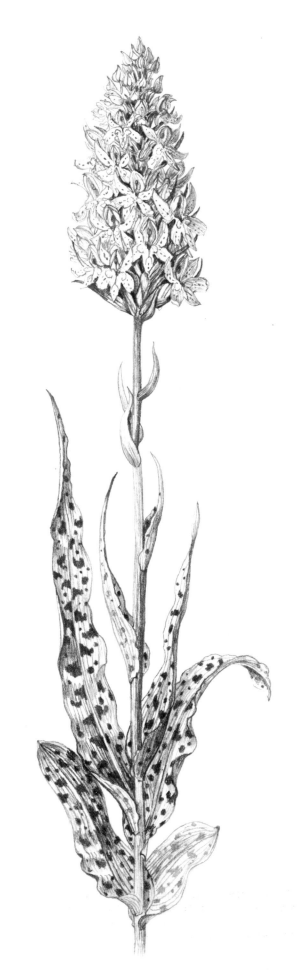

LET'S START PAINTING

Getting the greens right

With most greens the temptation to be lazy and use the colour straight from the tube or pan must be avoided from the outset. There are a few exceptions: I think the five watercolours I have shown on the five leaves in **fig. 35** are perhaps the only ones which are sufficiently true to nature to use occasionally on their own without mixing them with other colours. Of the five, Oxide of Chromium is the most permanent and a rather opaque paint; Terre Verte brings a lovely soft blue-grey tone to pine needles, etc., but it is slightly greasy and not easy to apply well over a large area; Hooker's Green Dark is only just acceptable as a colour for leaves, and should be used sparingly; Sap Green and Olive Green are not always permanent.

Green in all its infinite variety is the colour you are going to need more than any other, for all or nearly all plants have some greenery attached to them at some time of the year, and thank heavens for its comfortable, easy on the eye, cooling tones and its ability to separate and complement all the other brilliant colours of nature in general and the garden in particular. Just imagine the horrific effect of a flower border crammed with reds and pinks, magentas and oranges if there was no sea of green to separate them into islands of acceptable shades.

There are many people who see colours differently – some are colour-blind and find red and green difficult to distinguish, as they merge one into the other; I can only go by the way I see colours myself, but I often think I am over-sensitive to green in particular, and there have been several occasions when my quiet, restrained greens have been over-printed in too bright and harsh a tone, which has worried me considerably. Any emerald green should be avoided by the flower painter. This includes several of the hard, vivid blue-greens found particularly in the gouache range of colours. Three of these, two gouache colours and one watercolour, are shown in **fig. 37**. If you are designing fabrics, or household goods – or choosing a ring – emeralds are acceptable, but no leaf in the world is like them. Use one of the greens shown in **fig. 35**, or one of the mixtures of colours in **fig. 36**, or a combination of straight primary shades, and keep your greens quiet, cool and a suitable background to flowers.

The bryony leaves in **fig. 38** have been painted in a mixture of pale yellow, Viridian and Sepia, an unconventional mix, but it works. (Although Viridian should never be used on its own for leaves, it is useful in mixes.) The area marked a1 has had one flat layer of paint applied, with no attempt to vary it. In a2 some of that colour has been lifted off with a slightly damp brush before the paint has set, to give the leaf a light shine and to indicate the veins. This is easy to do on Fashion Plate HP paper, as the paints mostly sit on the surface and can be removed later if necessary, but rougher or thin papers do not respond quite so easily and can be damaged in the process. When using such papers it is better to leave the highlights unpainted and mark the pattern of the veins before you start, as in b1. The lowest leaf shows how you can get much the same effect by using either method. In a3 more shading and colour have been added to emphasize the pattern of the veins, and in b2 the edges of the highlights have been softened.

Fig. 35

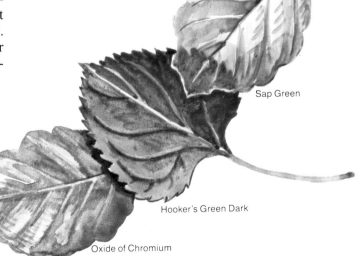

Terre Verte

Sap Green

Hooker's Green Dark

Olive Green

Oxide of Chromium

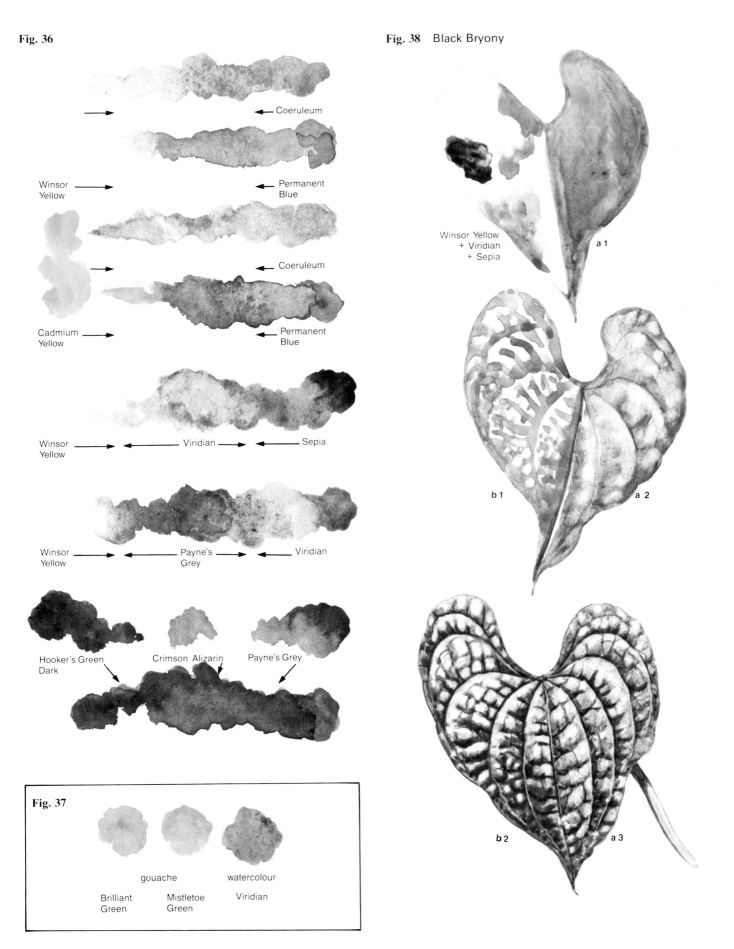

Fig. 36

Coeruleum

Winsor Yellow → ← Permanent Blue

Coeruleum

Cadmium Yellow → ← Permanent Blue

Winsor Yellow → ← Viridian → ← Sepia

Winsor Yellow → ← Payne's Grey → ← Viridian

Hooker's Green Dark Crimson Alizarin Payne's Grey

Fig. 37

gouache watercolour

Brilliant Green Mistletoe Green Viridian

Fig. 38 Black Bryony

Winsor Yellow + Viridian + Sepia

a 1

b 1 a 2

b 2 a 3

27

Fig. 51 Cornfield flowers, first stage

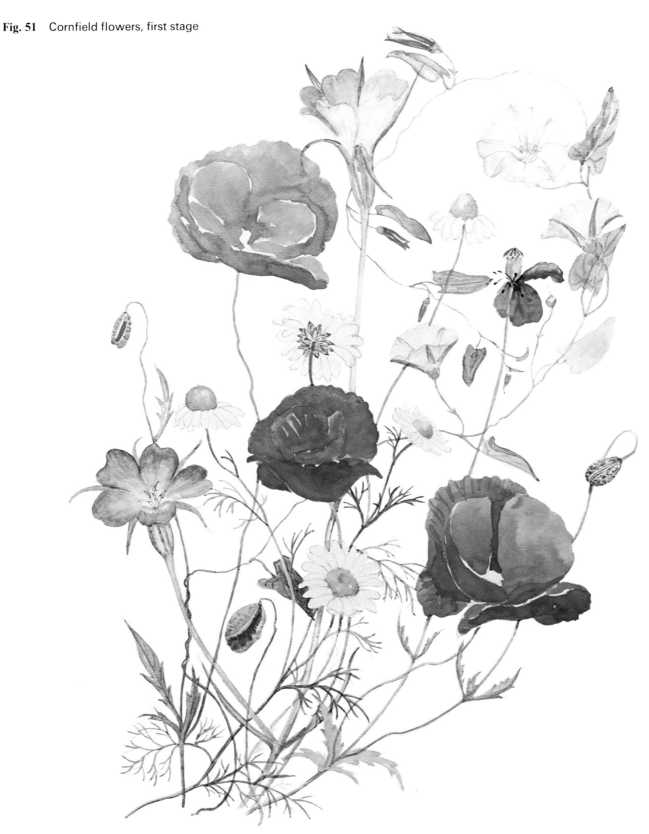

First stage It is first necessary to decide on the composition of the picture, with the correct placing and number of flowers required to make a pleasing but uncrowded bunch. I want it to look light and delicate, without too many contrasting colours, which is why I have substituted the Scentless Mayweed for the Corn Marigold. After lightly pencilling in the position of each flower, I have painted the first washes of colour in the way I have already demonstrated (pages 30 to 33), using Cadmium Red plus a little yellow for the poppies.

Fig. 52 Cornfield flowers, finished painting

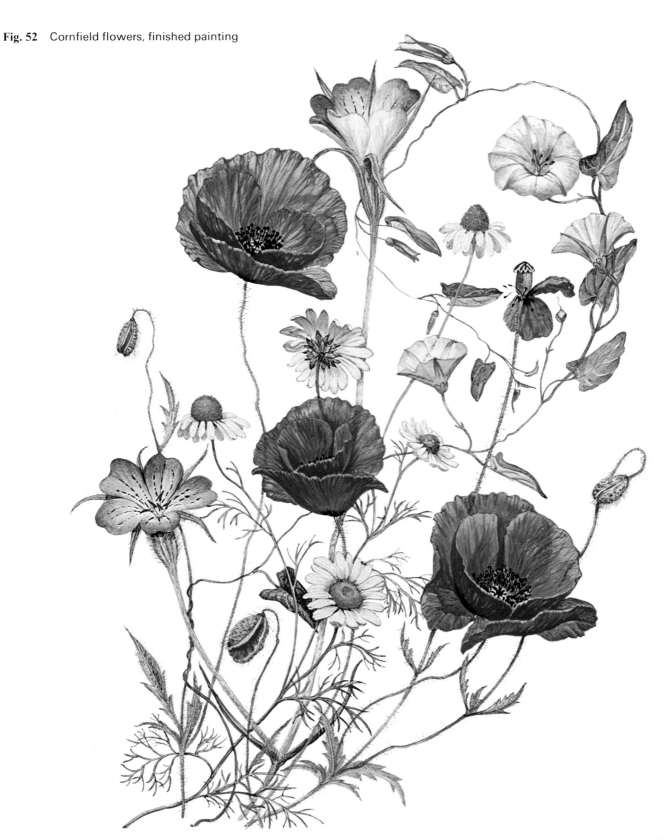

Second stage Because the basic layer of paint for the poppies and bindweed has been kept very pale, it is possible to achieve the appearance of thin, transparent petals by adding the creases in deeper shades. The shadows on the petals of the mayweeds have been painted in tones of greeny-grey. It is important to pay great attention to the fine hairs on the various stems and leaves. A magnifying glass is helpful. Use a brush with a good point, and paint the hairs delicately and carefully in a soft colour. Never use black.

Surfaces, shadows and highlights

When you stop to consider all the parts of a flower you will realize how important it is to depict them correctly in order to bring out the plant's essential quality. It is no good painting the flower beautifully if it is attached to a stem which looks like a flat piece of green ribbon.

The way to make stems and berries shapely is to keep the highlights bright and clean and the shadows in the correct places. Some stalks and berries are matt, but they will still have a shady side to them. If you look at the pair of cherries illustrated in **fig. 53**, you will see that the one on the left is shiny but is just a flat disc; the other has had the shadow added, which immediately makes it appear more rounded. The same principle applies to painting the berries of hawthorn and bryony, and to some extent to painting sloes. But the sloes have over their highlights a grape-like bloom of a soft shade of mauve-blue.

I have chosen lungwort and holly as examples of leaves because they are not only obviously unlike in shape, but also very different in every other respect. Lungwort is pale-spotted, soft and hairy. You can use a fine-pointed brush to stipple in the hairs over your initial wash of pale green, leaving the spots showing as you proceed. Or you can painstakingly paint each hair. Or, if you do not want such a close-up, detailed portrait, you can roughly stipple all over using a worn-out brush and 'add' the spots afterwards by removing some of the stippled paint with a damp brush. The holly leaf has a brightly coloured, polished and brittle look about it. The positions of the highlights are important and are best marked lightly with paint or pencil at the start so that you can leave unpainted areas in the correct places and then soften or stipple round them as you paint the rest of the leaf. Do not forget to give the leaf its pale yellow margin.

Another plant with almost white edges to its leaves is the Alpine Lady's Mantle. The leaves are dark, smooth and shiny above – a mixture of Hooker's Green Dark, Payne's Grey and Raw Umber – but in contrast the underside is the palest almond silk and softly hairy. I like to use a thin wash of Terre Verte with a little Lemon Yellow here and Davy's Grey or Coeruleum there, and when the rest of the leaf is dry I add the hairs with white paint.

Fig. 53

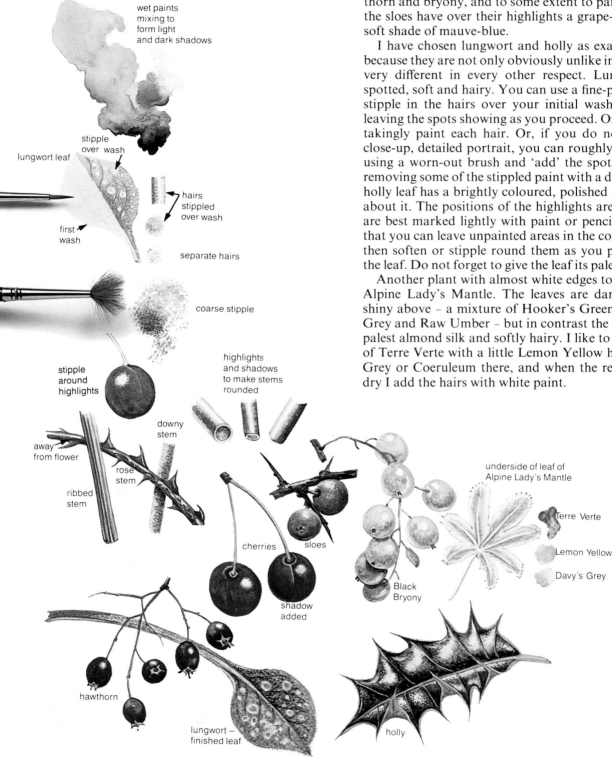

wet paints mixing to form light and dark shadows

stipple over wash

lungwort leaf

first wash

hairs stippled over wash

separate hairs

coarse stipple

stipple around highlights

highlights and shadows to make stems rounded

downy stem

away from flower

rose stem

ribbed stem

cherries

sloes

shadow added

underside of leaf of Alpine Lady's Mantle

Black Bryony

Terre Verte

Lemon Yellow

Davy's Grey

hawthorn

lungwort – finished leaf

holly

36

Shapes, spots and stripes

I am deliberately suggesting that for once you copy the flower portraits on this page (**fig. 54**), as an exercise in how to achieve the correct basic shape of different flowers. Some are simple and easy to do. Many are contained within a circle. A modern hybrid rosebud is triangular. But a daffodil is much more complicated, and three circles are involved.

You should practise drawing the daffodil as though it were made of glass, so that you can accurately position the sixth petal, which is almost always hidden behind the trumpet, and fit the long neck of the flower into its column.

Learn how to control your brush when applying fine details such as spots and stripes, which require only a steady hand, a fine brush and nothing more, or less, than continual practice to make perfect.

Fig. 54

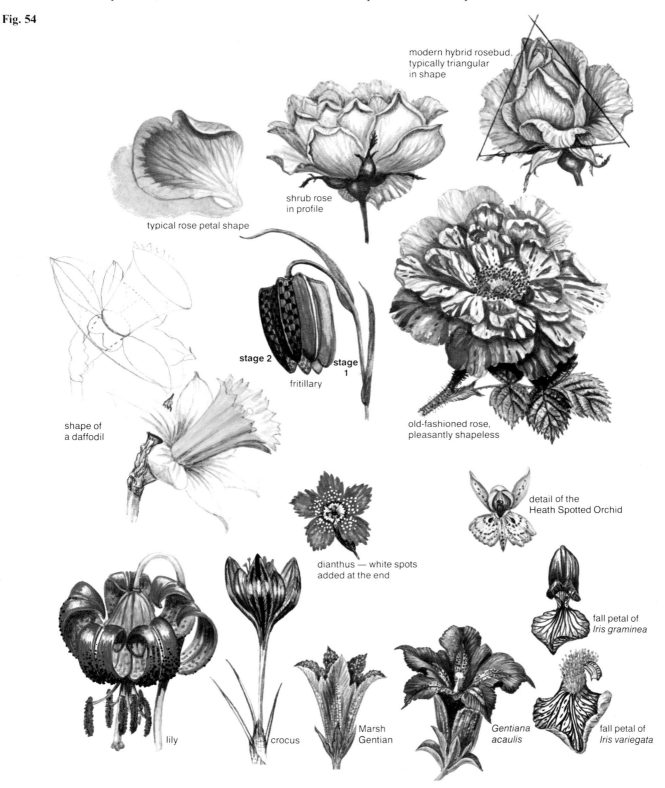

modern hybrid rosebud, typically triangular in shape

shrub rose in profile

typical rose petal shape

stage 2 stage 1
fritillary

shape of a daffodil

old-fashioned rose, pleasantly shapeless

detail of the Heath Spotted Orchid

dianthus — white spots added at the end

fall petal of *Iris graminea*

lily crocus Marsh Gentian *Gentiana acaulis* fall petal of *Iris variegata*

Painting white flowers

White on white I have always liked white flowers and have now discovered how fascinating they are to paint. To begin with you may think that it is impossible to reproduce white flowers successfully in watercolours on a white paper without a painted background, but it can be done. In a medium such as oils, where darker backgrounds are normally added, they may be far easier to paint but they will look less ethereal. It is the effect of white against white that I love. I cannot bear a black outline to any white flower; it looks hard and unnatural, although it is often used in book illustrations; I prefer a grey tone. I start with a *very faintly* marked outline, a mere touch here and there to guide me, using palest grey paint. You can use pencil if you prefer, but only the lightest possible marks. I then like to watch my flower gradually emerge as I paint the shadows. These vary in tone according to the plant. They may be blue-grey, or tinged with cool yellow, or plain grey, such as Davy's Grey, which I use for some flowers, occasionally on its own or more often mixed with various colours. Or I might use Payne's Grey, or Neutral Tint, or a mixture of colours excluding the greys. Do not be afraid to experiment with your colours, for white flowers are like a mirror and reflect many shades. If your flower is surrounded by leaves then these will provide you with a natural background and fewer shadows need be added on the flower itself, but do not be tempted to twist leaves at awkward-

looking angles or paint them in places where they do not normally grow, just to avoid having to tackle the not really too difficult task of white against white. When you first begin, gradually build up your shadows in layers of paint until you are satisfied that they are deep enough and that they have fulfilled their purpose, which is to give form and shape to your flower. When you feel more confident, you can apply your paint in one bold layer if you prefer. Remember that there is often a pale edge to a turned-down petal which will make it stand out and 'lift' it above the shadow it has cast, and also there will probably be a reflection of green from a leaf on the underside of a petal, which adds a subtle touch of colour to the flower.

There is no need to use white paint for flowers on white backgrounds. The paper provides pure, clean spaces between the shadows of a whiter white than you can ever achieve with paint. Whatever you do, carefully protect these clean areas until the very end; don't get into the habit of dabbing unnecessary bits of shadow here and there or you will finish up with an over-all dirty-grey flower. If there are several flowers in the picture then a few at the back of the bunch, or underneath the main flowers, can be painted completely in shadow, which will greatly help to emphasize the ones that are in the light, giving a three-dimensional effect which is lovely to achieve. If your painting still looks flat, add a little deeper tone to existing shadows, gradually building them up until the flowers have shape and form but have not lost their pristine white highlights.

Fig. 55

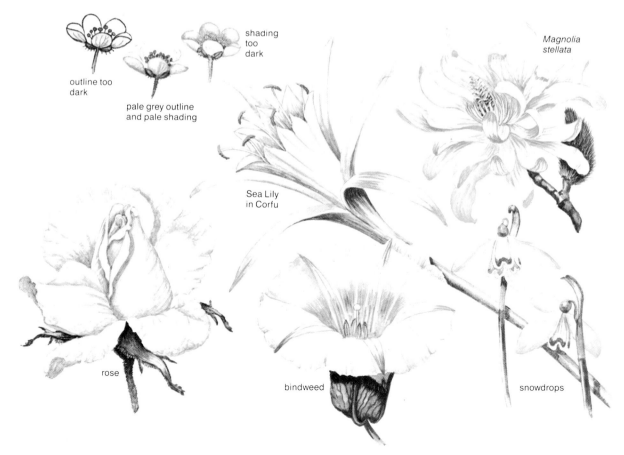

outline too dark

pale grey outline and pale shading

shading too dark

Magnolia stellata

Sea Lily in Corfu

rose

bindweed

snowdrops

38

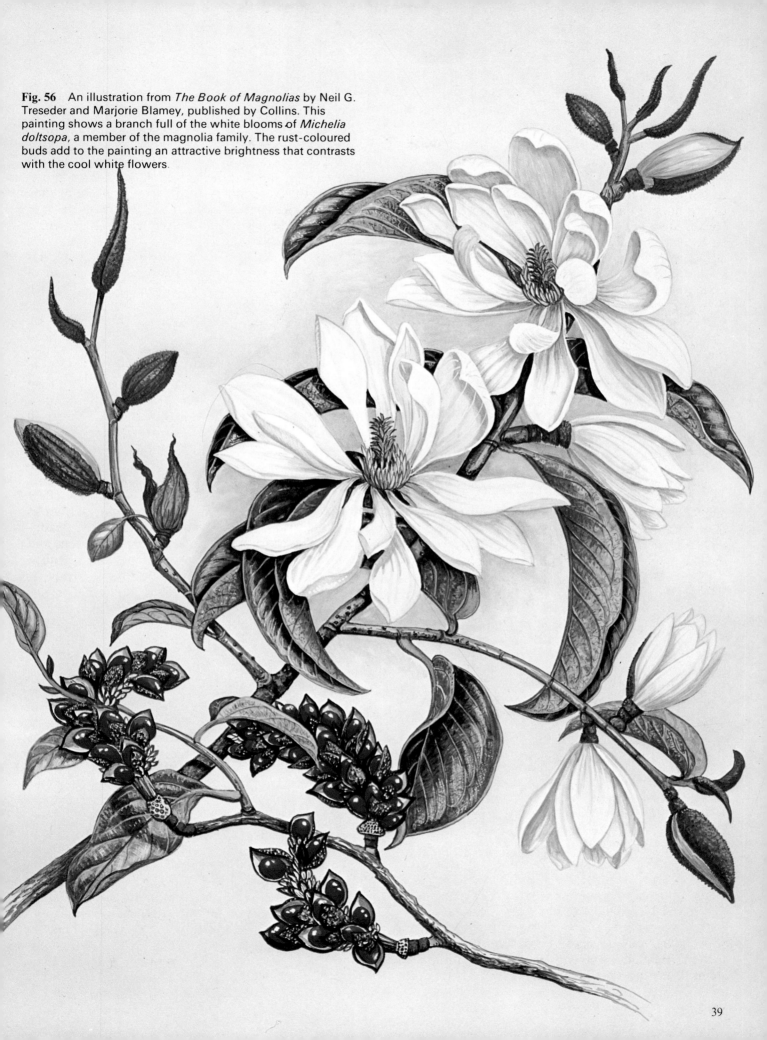

Fig. 56 An illustration from *The Book of Magnolias* by Neil G. Treseder and Marjorie Blamey, published by Collins. This painting shows a branch full of the white blooms of *Michelia doltsopa*, a member of the magnolia family. The rust-coloured buds add to the painting an attractive brightness that contrasts with the cool white flowers.

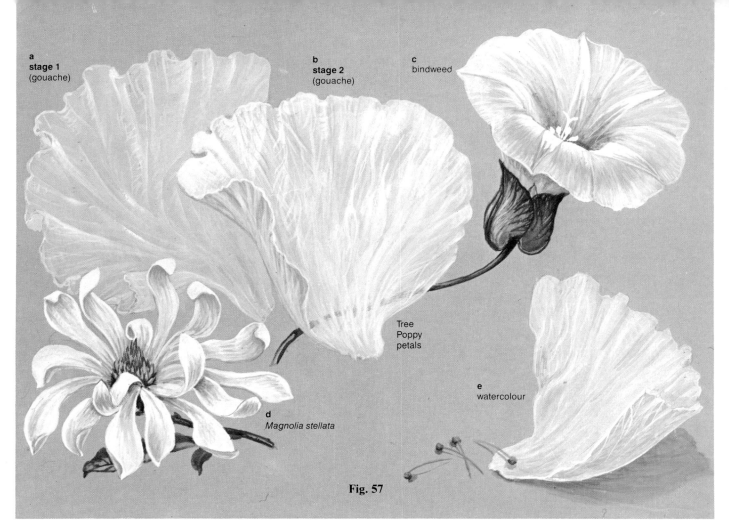

a
stage 1
(gouache)

b
stage 2
(gouache)

c
bindweed

Tree
Poppy
petals

d
Magnolia stellata

e
watercolour

Fig. 57

White flowers on tinted paper As I have already mentioned, gouache paints are particularly effective on tinted paper. However, if you have no gouache available, watercolours too are perfectly suitable for use on the paler papers. I used white gouache paint for the petals of the Californian Tree Poppies in **fig. 58**, but the rest of the painting, including the stamens, was done in watercolours. In **fig. 57e** I also used watercolour for one petal, in order to prove the point. The grey paper I used for the Tree Poppies painting is not specially made for the watercolourist. I found it at our local printers'; it is thick enough to take paint well and is in a cool, neutral shade of grey I wanted when I illustrated *The Wild Flowers of Britain and Northern Europe*. I used it for some of the pages of mainly white flowers in that book and have used it for a great deal of other work since then. It is a useful tone for this demonstration, for it is darker than the petals but paler than the shadows on stems and leaves. In **fig. 57** I began to paint my white poppy for you by lightly marking in the outline, using white paint here and there; if you prefer to use pencil, keep it very faint. When you become accustomed to the shape of the flower you can apply your first thin wash of colour all over the petals without bothering to do the outline, which gives you a lovely feeling of freedom and satisfaction. In **fig. 58** I only marked in the position of the stems. I like to vary the opacity of this first thin layer

of paint by adding more water here or extra paint there (**fig. 57a**) to get the effect of shadows and highlights and the extreme thinness of the petals of these beautiful flowers, which grow in our garden and look like ballet dancers in white tutus. If you like to leave one or two flowers half-painted you can get an attractive out-of-focus and distant look to them which greatly emphasizes the more detailed flowers in the foreground. This gives your painting depth and distance, the three-dimensional look which I like so much. After the first wash you can then add to the more opaque areas, where the petals overlap for instance (**fig. 57b**), but do not apply too much paint for these or for any other transparent flowers, such as bindweed (**fig. 57c**). A painting of bindweed on white paper is illustrated in **fig. 55**; you can now compare the two ways of depicting this same flower. You can also compare the painting of *Magnolia stellata* (**fig. 57d**) with the one on white paper in **fig. 55**. As with all the species of magnolia with petals which look and feel like soft white kid leather, more paint is required to get the 'feel' of the thicker, opaque petals. Allow white paint to dry and harden thoroughly before adding stamens to your Tree Poppies, or shadows to any thicker-petalled flowers.

The stems and leaves of the Tree Poppies in **fig. 58** have been painted in Terre Verte watercolour, with touches of yellow and of Payne's Grey in the shadows. White highlights help to round off the stems.

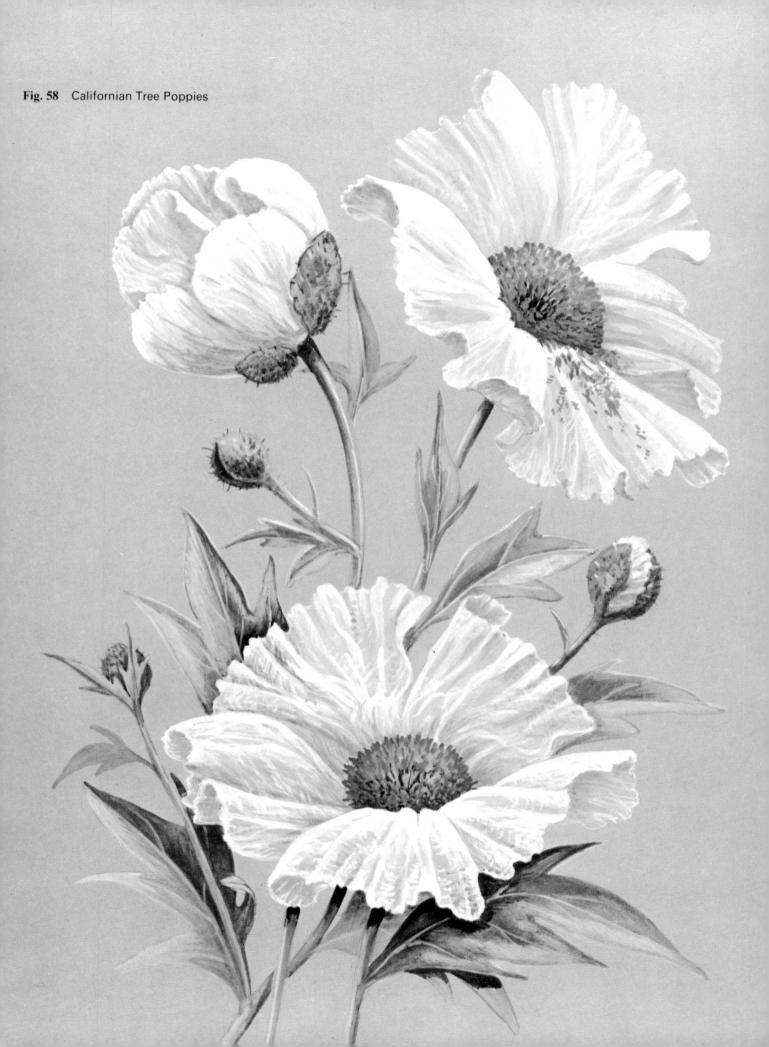

Fig. 58 Californian Tree Poppies

More tinted papers

The tinted papers shown in **fig. 59** are designed to take pastels. However, they are suitable – and exciting – to use for watercolour paints, provided that you either buy them ready-mounted or mount them yourself. Even the thicker unmounted papers will cockle if water is applied. To mount the paper, spread wallpaper paste on the back, allow the paper to stretch for five minutes, then gently smooth and roll it, under a sheet of clean paper, on to a piece of firm card or hardboard. Other tinted papers are made specifically to take water paints and will not need to be treated first. To illustrate the effect of painting on different-coloured papers, on two of the papers in **fig. 59** I have shown a rose and two petals from the first stage of my painting of summer flowers (**fig. 60**).

Fig. 59 Tinted papers

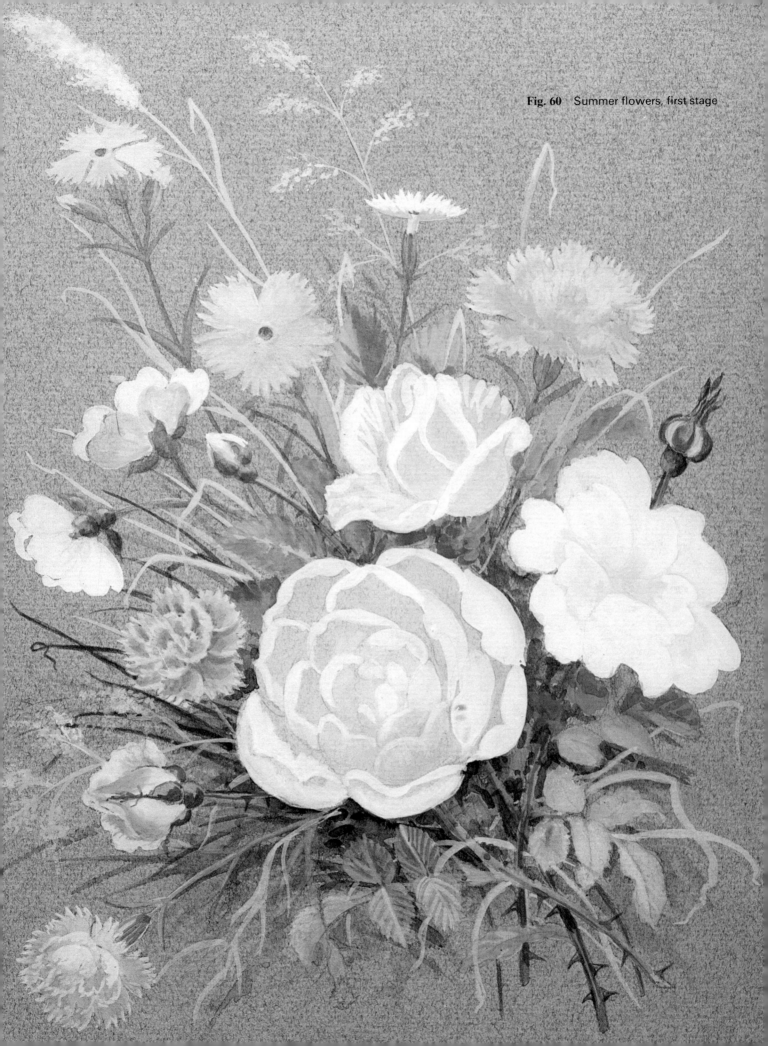

Fig. 60 Summer flowers, first stage

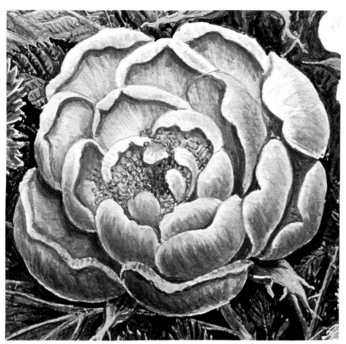

Fig. 61 Rose, detail from fig. 62

Summer flowers

Fig. 60 shows the first stage of a painting of a bunch of summer flowers on a dark-tinted pastel paper.

First stage I painted *all* the flowers in white gouache in the way I showed you with the Tree Poppies on pages 40 and 41. I allowed the paint to harden thoroughly for a whole day and then began a second coat, using both watercolour and gouache in various shades. I began the leaves in Terre Verte and a mixture of blue and yellow, with a little white. As the picture progresses I will add a film of deeper tones.

Second stage My reason for allowing the first layer of white paint thoroughly to dry and harden is that I do not want it to 'cloud' the top layers of colour (and also possibly cause them to fade in time) by getting mixed in with them. I merely want it to act as a base to the pale shades in the flower which I have painted on top of the white and would not otherwise be able to achieve using water-based paints on very dark paper.

The finished painting is illustrated in **fig. 62**. You will see how additional layers of colour have been added and how the important details, the highlights and shadows in the roses and the garden pinks, make the flowers appear more full, rounded and alive. As the final touch white was added to pinpoint the brightest highlights of the painting.

The rose which has been plucked from the finished painting and is illustrated in **fig. 61** as well has had several layers of paint applied to it on top of the initial white, starting with pale Cadmium Yellow and continuing with ever-deepening shades of Cadmium Red and finally Crimson Alizarin, all softened and diluted with gouache in Naples Yellow and a little white. I used a mixture of Crimson Alizarin and Payne's Grey for the shadows, which I wanted to remain warm-toned.

The leaves throughout the finished picture have been painted in many shades from pale grey-green and yellow-green mixtures to deep tones of Hooker's Green Dark mixed with Payne's Grey and Raw Umber, to show you as much variety of tones as possible. Some heavy shadows help to emphasize the pastel tones of the flowers and some greens remain lighter than the tinted paper of the background, with attractive results.

This is a method of painting that is far removed from the pure watercolourist's style and technique. It is what I call 'fun painting'. I like to make my flowers stand out paler than the background; I like adding shadows that are darker than the paper; I enjoy working with water paints as if they were oils or acrylics and still being able to add finer details than I can with oils. I know I can obtain much the same effect using diluted acrylics, but I find watercolours more delicately toned, and more sympathetic to use.

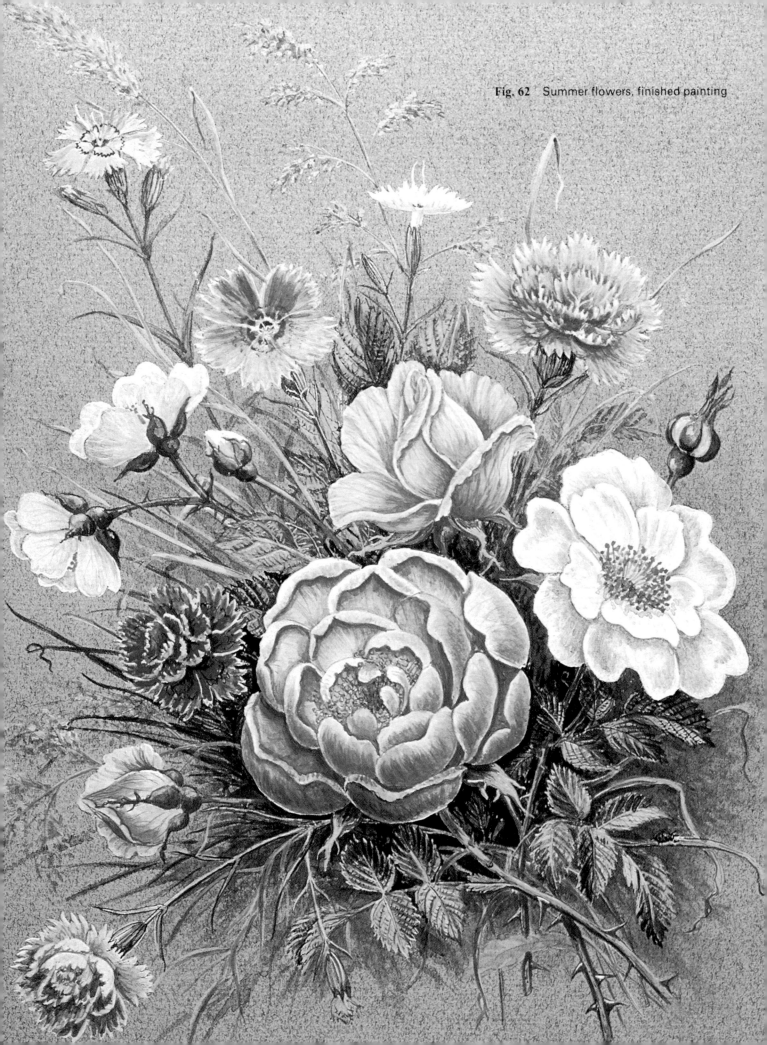

Fig. 62 Summer flowers, finished painting

PAINTING THROUGH THE SEASONS

Starting with spring

Spring begins early in Cornwall and I always resolve to paint the very first flowers to bloom in January and to continue throughout the year to fill my diary to overflowing with flower sketches. I rarely succeed with my annual pleasure much beyond March, but while it lasts it is a delightful occupation which I can thoroughly recommend, for it makes one observant and ever-watchful for new flowers, which is as exciting as painting them. In 1982 I began my diary in February, painting individual plants which caught my eye (**fig. 63**). First, the green-gold hazel catkins. Many people have eyes only for these showy male flowers and do not notice the tiny females bedecked with scarlet tassels which grow here and there along the branches, no

Fig. 63 Spring flowers

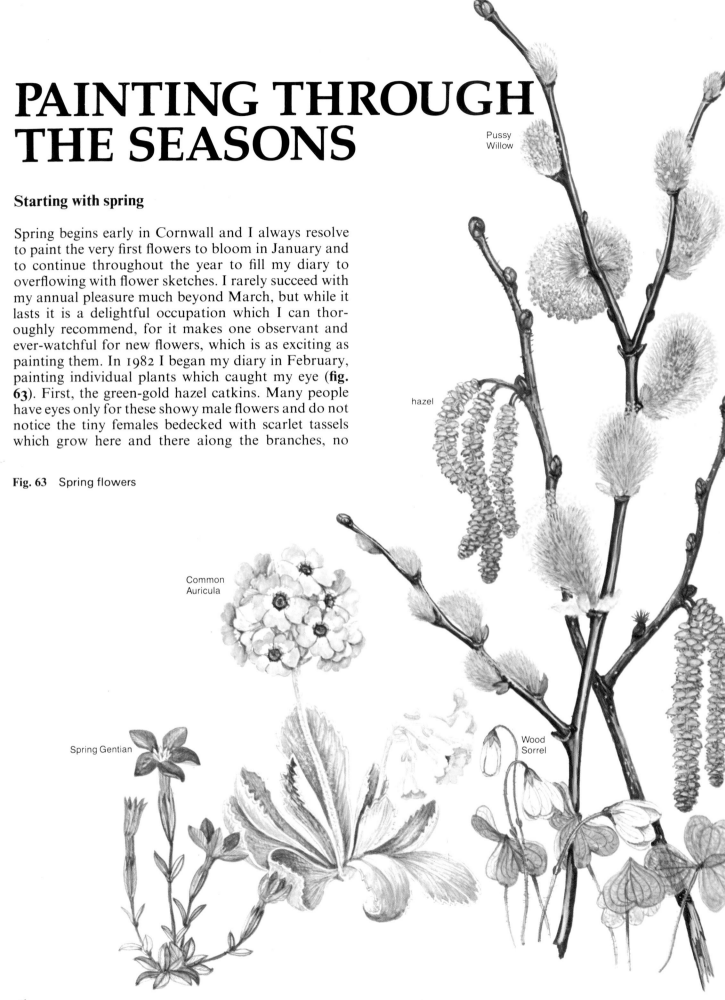

Pussy Willow

hazel

Common Auricula

Spring Gentian

Wood Sorrel

46

bigger than a grain of rice but capable of developing into bunches of nuts for squirrels, dormice and humans. The golden Pussy Willow was out early in March. It makes a lovely subject to paint for an Easter card and is not as difficult as it looks. Start with the pale grey silky body of the catkin – Davy's Grey is a good colour to use – and then add the fine hairs of the stamens and finally dot on the golden pollen-bearing anthers, using Lemon Yellow for the highlighted side and Cadmium Yellow Pale for the darker areas. Used fairly thickly the paint will 'take' over the grey background quite successfully. The delicately veined Wood Sorrel was soon blooming among our woodland trees and not long after, in my troughs of alpine plants, the Common Auriculas flowered. I like to paint their mealy white eyes and deep Cadmium Yellow faces. The leaves are satin smooth and blue-green. Terre Verte yet again proves a useful colour; note the pale edge to the leaves. The Spring Gentian is a tiny sapphire gem and is the only member of its true-blue family to grow in Britain, where it is rare and protected and must not be picked. Plants and seeds can be bought from nurseries specializing in alpines. It is possibly the clearest deep blue of British wild flowers, but it varies in tone from plant to plant. The best are pure cobalt but never as intense in colour as the more famous trumpet gentians, so paint them with a thin film of blue and then add a little deeper tone for the shadows.

Before I found time to paint primroses they no longer appeared here and there as pale, clear-toned individuals, for by February they had merged together and resembled bowls of luscious Cornish cream. I have painted a whole plant growing in a woodland setting and introduced for the first time in this book some of the natural objects which were tucked around it, such as dead oak leaves (**fig. 64**). These add interest to the picture, for they are part of the natural habitat of such a plant, and they are lovely to paint, using the good earthy shades of the Umbers and Siennas and Yellow Ochre. I would like to encourage you to paint litter; not the kind left around by humans but the litter of nature in the form of dying leaves and broken twigs under which you will discover many different-coloured mosses, lichens and fungi and 'wildlife' in the shape of ladybirds or a sleeping moth. This small world hidden beneath the woodland floors is fascinating to paint.

Fig. 64 Primroses flowering in a woodland setting

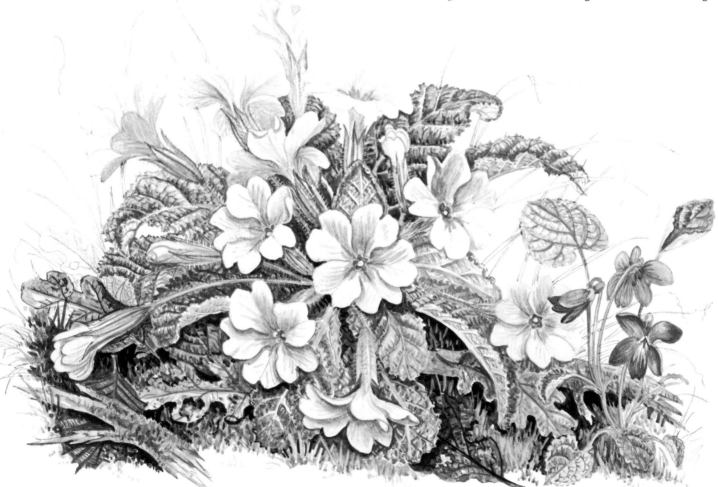

Composing the flowers of summer

It is very tempting to put too many flowers into a composition, particularly in summer when you feel you cannot bear to leave anything out. I have filled my bunch of summer blooms to the very limit but I have kept to old-fashioned cottage flowers in soft colours, which makes it acceptable in my eyes. I first picked a full-blown rose for the star role, then added lavender, sweet peas, a white lily and some tiny miniature roses, and finally a whole stem of fruit from the strawberry bed, because I liked the clash of colours and also because the scent of old roses and the taste of strawberries together epitomize summer. I first made a working sketch (**fig. 65**), placing the main rose near the base and the smaller flowers radiating out from it to avoid a top-heavy look. Last of all I placed the lavender at the back, to add height. It is strange, incidentally, how flowers in groups of three or five look more pleasing than groups of two or four. Then I tried out the various colours to see how they would blend together (**fig. 66**). These shades of pink, mauve and cream are very easy on the eye, and only the contrasting colour of the strawberry will have to be watched as the painting progresses.

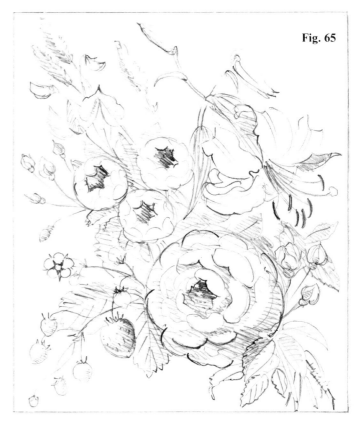

Fig. 65

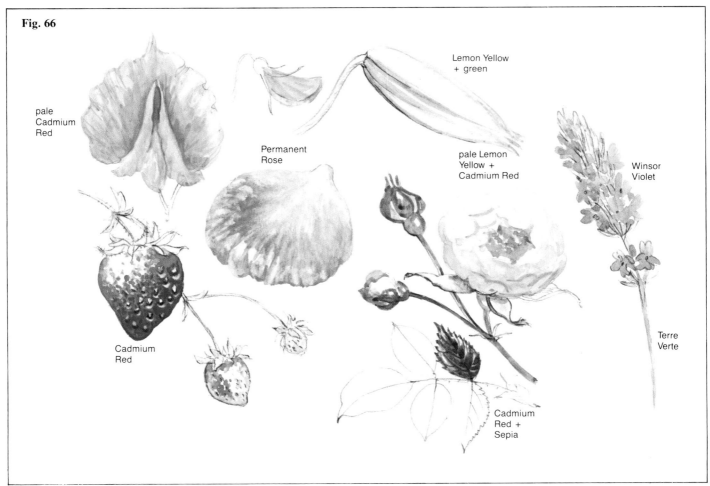

Fig. 66

pale Cadmium Red

Permanent Rose

Lemon Yellow + green

pale Lemon Yellow + Cadmium Red

Winsor Violet

Cadmium Red

Cadmium Red + Sepia

Terre Verte

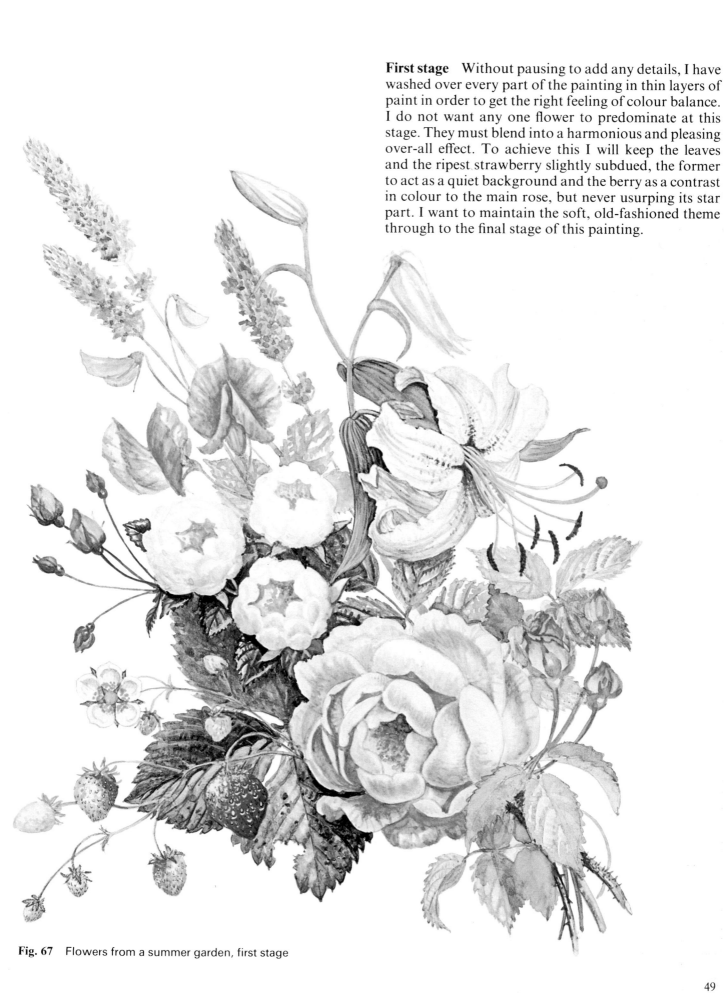

First stage Without pausing to add any details, I have washed over every part of the painting in thin layers of paint in order to get the right feeling of colour balance. I do not want any one flower to predominate at this stage. They must blend into a harmonious and pleasing over-all effect. To achieve this I will keep the leaves and the ripest strawberry slightly subdued, the former to act as a quiet background and the berry as a contrast in colour to the main rose, but never usurping its star part. I want to maintain the soft, old-fashioned theme through to the final stage of this painting.

Fig. 67 Flowers from a summer garden, first stage

49

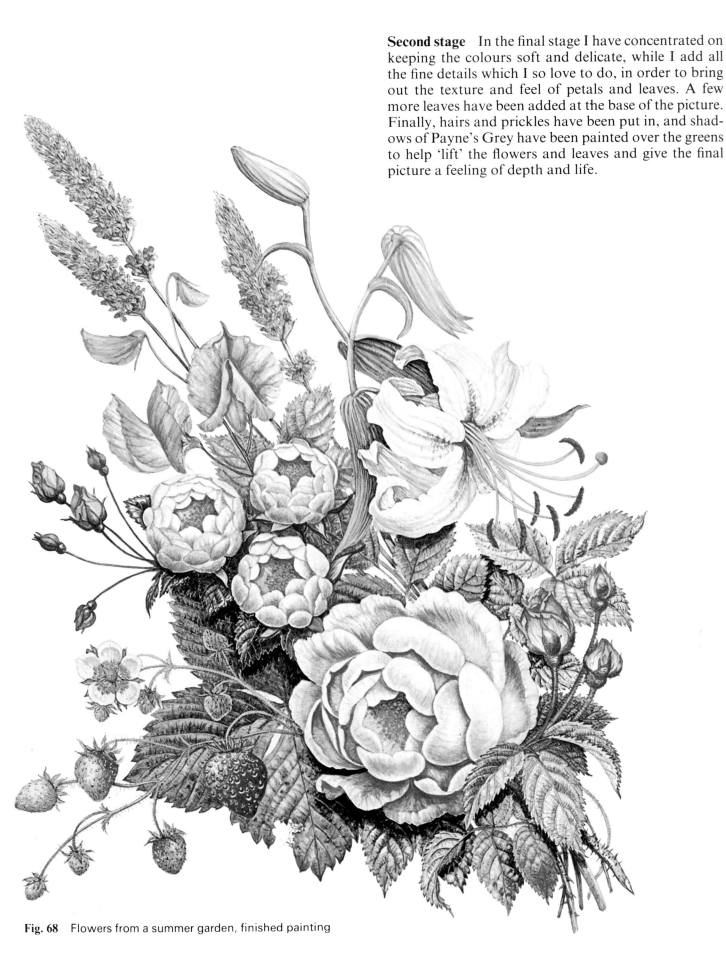

Second stage In the final stage I have concentrated on keeping the colours soft and delicate, while I add all the fine details which I so love to do, in order to bring out the texture and feel of petals and leaves. A few more leaves have been added at the base of the picture. Finally, hairs and prickles have been put in, and shadows of Payne's Grey have been painted over the greens to help 'lift' the flowers and leaves and give the final picture a feeling of depth and life.

Fig. 68 Flowers from a summer garden, finished painting

Fig. 69 Hedgerow findings

blackberries

stage 1

stage 2

Old Man's Beard

Cadmium Yellow Cadmium Red Permanent Blue = Black

spindle berries

dandelion clock

Permanent Rose

Cadmium Yellow + Cadmium Red

stage 1
Cadmium Yellow

stage 2

blackberry leaf

Autumn tints

The colours of autumn are altogether different from the ones I used for my summer flowers. They are much deeper, but the lovely muted shades of Yellow Ochre, the Umbers and Siennas of the dying leaves mix well with the occasional brilliance of wild berries.

The leaves of the ornamental garden trees, such as maples, cherries and sumachs, usually produce bright and beautiful flame colours, but I am leaving the garden this time and looking for wild fruits and berries in the countryside for my painting (**fig. 69**). Blackberries always attract me as a painter; the unripe berries start green and gradually turn a soft crimson and finally black, not a dead black but a colourful black which is far better mixed up from the primary colours, using Cadmium Yellow, Cadmium Red and Permanent Blue, than taken straight out of a tube of ready-made black paint, with its rather lifeless shade. You can vary and control the mixed colours so much better and they are far more luminous. Some berries will show purple shades. I have illustrated two stages of painting a ripe fruit: keep your initial wash pale (stage 1), and add more layers until you have the depth of colour you want, taking care to leave highlights in each of the small seed-bearing berries which make up the whole fruiting head (stage 2). A wander round the country lanes produced, among other things, a dandelion clock, which wafted its seeds to the winds before I could get it home safely but still looked attractive enough to

paint. I also found a small branch of wild spindle with berries of a lovely rose pink; when a berry splits open to reveal the orange seeds there is an exciting clash of colours. I used Permanent Rose for the overcoats and a mixture of Cadmium Yellow and Cadmium Red for the berries. (If you pick spindle berries, remember that they are poisonous, and do not leave them lying about where children may find them.) Blackberry leaves are very variable, not only in the colour of their dying but also in shape, which is not really surprising once you realize that there are almost three hundred different kinds of blackberry growing in Britain alone, each one varying in some small way from the next, perhaps only in the shape of the thorns, or the amount of hairs on the leaves. The colours of the flowers vary from white to mauve-pink. For our purpose I am content to call a blackberry a blackberry and to paint a fallen leaf which caught my eye because it was pure gold over much of its surface. First I brushed a layer of Cadmium Yellow over the whole of the leaf (stage 1). On top of this, while it was still damp, I added a wash of exactly the same mix of colours that I used for the ripe blackberry. The mix merged into the yellow and made an attractive purple-brown tone (stage 2). The final details, the veins and wrinkles, followed when the paint was dry and can be seen in **fig. 70**. The seedheads of Old Man's Beard help to make any autumn picture attractive, for they are ghostly and quiet and fill in the background without being too dominant. I added a quick pencil sketch to remind me to include some in the final painting.

Having decided I would like a tinted background, I have chosen a cream paper on which to paint my wild autumn harvest. The cream is a warm tone and yet pale enough to take watercolour successfully. The blackberries have been reunited to their stems in order to show you how they grow. I have completed their leaves and added a dead leaf. I have painted some rowan berries too, for they may come in useful one day. I like to take time off occasionally to add to my collection of working sketches. A fresh dandelion clock reached my studio in perfect condition ready for the final painting, and so did some ivy berries, picked before the wood pigeons could devour the lot; they and the beech leaves are quiet-toned and fit easily into any scheme.

The painting in **fig. 71** was designed with two purposes in mind: first, to show you as many different fruits and leaves of autumn as I could fit in; and, secondly, to warn you not to overcrowd your paintings. It would be far more pleasing to the eye if I had put fewer plants into this picture, for these autumn twigs and branches are spiky bedfellows with awkward limbs and do not fit together so comfortably or harmoniously as flowers do. So when you are planning your design you should remember that if in doubt, leave out – or paint two pictures instead of one.

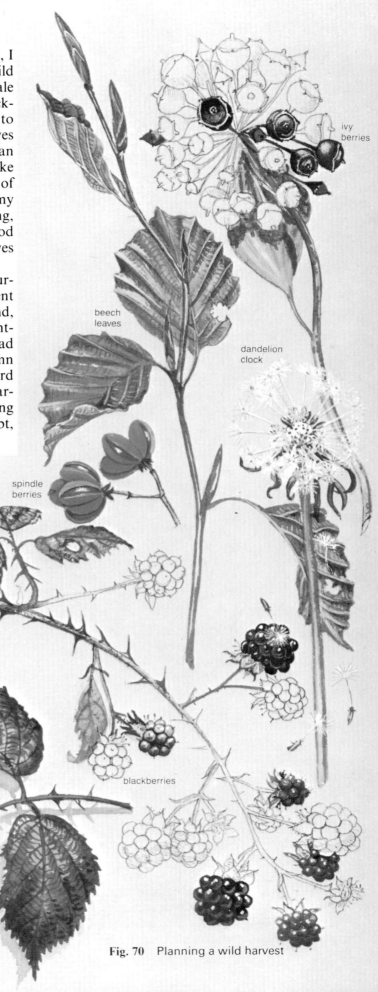

ivy berries

beech leaves

dandelion clock

spindle berries

rowan berries

blackberries

blackberry leaves

Fig. 70 Planning a wild harvest

52

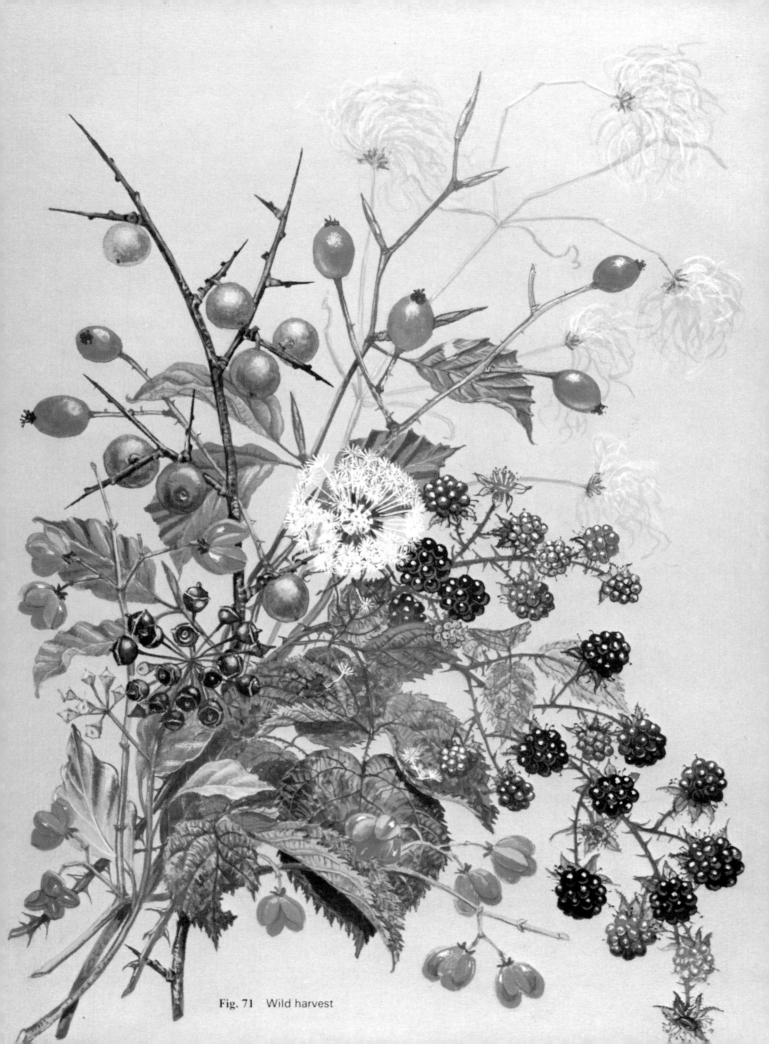

Fig. 71 Wild harvest

Winter shades

Even in a hard winter when the countryside has little to offer the painter, a garden can usually be relied upon to produce some flowers from a sheltered corner. In the mild winter of 1982 the spring flowers arrived very early. But although they were most welcome, I did not think cherry-pink polyanthus exactly fitted the spirit of the dying year. The pale mauve winter-flowering *Iris stylosa*, the delicate Winter Cherry and the snowdrop more truly represented the garden in its last season of the year (**fig. 72**). A pale wash of Winsor Violet mixed with a hint of Cobalt Blue was perfect for the iris. The fine markings were added when the paint was dry. The delicately tinted cherry blossom always looks washed out by the winter rains, but manages to bloom on and off throughout the coldest months of the year. To get the right effect you need only a touch of palest Crimson Alizarin or Permanent Rose on your wet brush. The snowdrop was painted in the same way as the white flowers described on page 38.

The small, buttercup-like flowers of Winter Aconite have a delightful ruff of green leaves round their necks. Although they are classified as wild flowers, in Britain they are more often seen in cultivation and spread like weeds in gardens they happen to approve of. They obviously do not approve of ours, which is probably too acid for their tastes. For the snow scene in **fig. 73** I combined working drawings of plants from locations as far apart as the Royal Horticultural Society gardens at Wisley in Surrey, where I sketched the aconites, and our own home in Cornwall, where in the hard winter of 1981 I sketched a large clump of snowdrops which I had dug up and planted in a bowl while they were in full flower. They never object to such treatment and it is a great luxury for me to be able to sit and sketch or paint flowers in warmth and comfort at home, while outdoors a typical Cornish gale is lashing the garden, or snow is falling.

Painting from sketches is less satisfactory than working from live material but it is better than not painting at all, and if you take care to date your sketches and make notes of where you found the flowers, their particular habitats and which other plants grew around them, you can choose compatible partners and plan a grouping that looks natural.

And so I come to the end of this diary for all seasons with two very different paintings; the one in **fig. 72** shows the flowers I picked on a warm winter's day and painted while they were still fresh, and the one in **fig. 73** shows flowers painted from previous sketches and from memory.

Fig. 72 Winter flowers

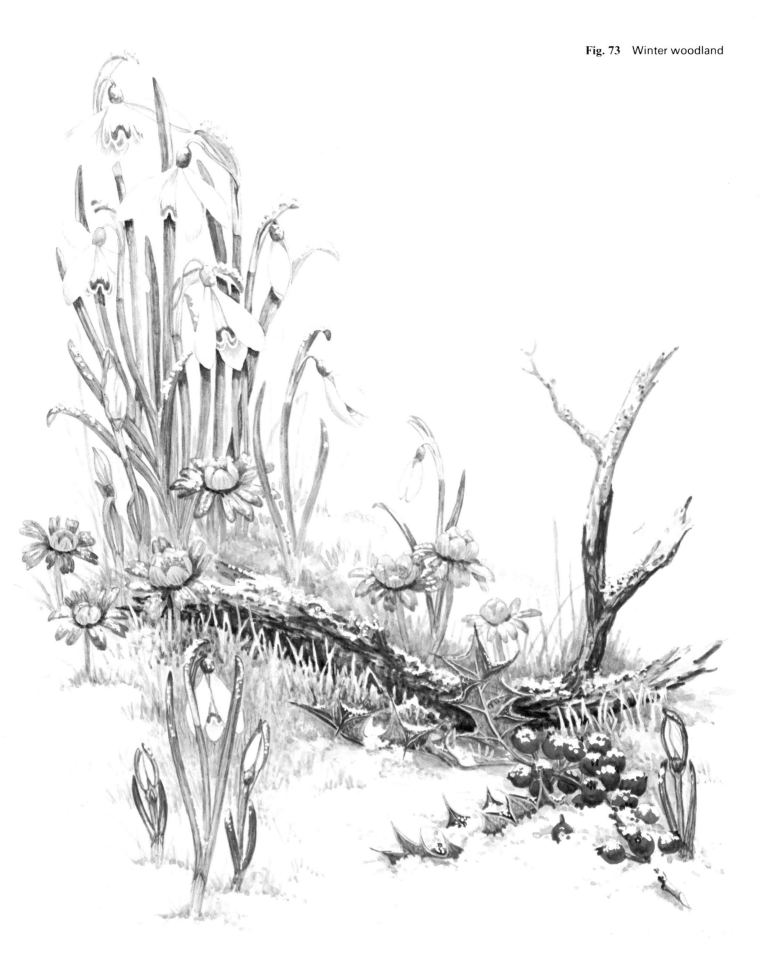

Fig. 73 Winter woodland

THE BROADER VIEW

There are surprisingly few days in the year when one can paint outdoors in real comfort. It is either too cold and windy or too hot, and then the paint dries before one has time to complete a sky. But I enjoy painting outdoors enormously – in retrospect. So let's take out that uncomfortable little stool, to discover that there is no shade whatsoever at the place we want to paint the view, so that the paper, balanced somewhat precariously on our knees, almost blinds us with its glaring whiteness. It is at this point that I begin to wish I used oils and could stand comfortably in front of my easel placed where no sunlight could fall on it; but we are supposed to suffer for our art's sake, so swat the midges and for the first time in this book I am going to paint some flowers within a landscape, with sky, trees and distant views as well as detailed foregrounds. It is the very best way of capturing the spirit of a holiday spent in the countryside; or of showing off your flower-filled summer garden to friends in the depth of winter. It is far more personal and satisfying than clicking away with a camera. Other people can do that; you can be different. It will certainly take more time than photographs, but it is worth every moment you can spare.

If you decide to start with your garden views you can sketch in comparative ease, so take out a comfortable chair and a small table, find a spot in the shade and choose a subject that is not too difficult to begin with, perhaps a small paved terrace with a pot of geraniums, or part of an herbaceous border rather than a large vista. If possible leave your pencils behind or only use them lightly to mark in the positions of certain objects, such as steps, or tubs of flowers; never pencil in the clouds, for you will not be able to rub out the lines after you have painted over them and they will show through the pale blue you use for the sky.

I painted the alpine garden picture (**fig. 74**) for our book *Flowers of the Countryside*. This painting is an example of a fairly straightforward copy of a view – of part of our garden – but a view complicated by a patchwork of many different miniature plants, which have to be portrayed in a certain amount of detail in the foreground in order to make them recognizable, but which can be merged and mixed together in the background. Too much detail in the distance would have spoiled the far-away and out-of-focus effect I wanted to achieve.

The sky plays a small and unimportant part in the alpine garden painting, but there are times when it becomes the dominant feature and occupies a large area of the painting, as **figs. 75, 76 and 77** illustrate.

Fig. 74 The alpine garden at Trelidden, an illustration from *Flowers of the Countryside* by Philip and Marjorie Blamey, published by Collins

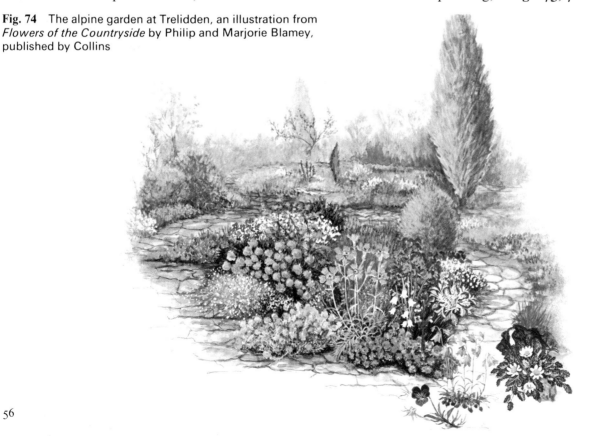

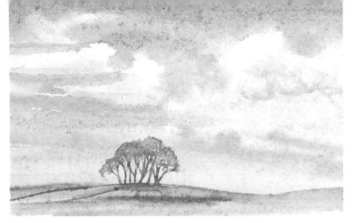

Fig. 75

Fig. 76

Fig. 77

Fig. 78　A bluebell wood

Begin by planning where you want your skyline – preferably off-centre – and with a sponge damp your pre-stretched and well-secured sheet of thick paper – not, please not, a flimsy piece torn from a cheap sketchbook, for it is not worth the effort of trying to apply really wet washes of paint over rapidly corrugating waves of soggy paper. Paint small 'skyscapes' all over your page and at all seasons of the year. The colours you use will vary according to weather. The first of my thumbnail sketches (**fig. 75**) shows a winter sky. I painted the palest clouds first in a mixture of French Ultramarine (or Payne's Grey), with Crimson Alizarin and Yellow Ochre. This combination produces a variety of tones from almost lavender to biscuit or cool grey. While the first wash was still damp I added touches of Coeruleum between the clouds to suggest a cold, wintry blue. Then I painted the darker storm clouds. To this sketch I could add some foreground plants, such as teasels left standing through the winter months. The other two sketches (**figs. 76 and 77**) show summer skies. When you paint a blue sky, slope your board to allow the paint to flow with the brush. The blue is always palest near the horizon and darker in the heavens. French Ultramarine with a little warm Cobalt Blue gives the most suitable blues for summer skies. In **fig. 76** flowers have been painted in the foreground of the landscape. If the flowers are darker than the sky, as the poppies are here, they can simply be painted on top of the sky. Or, if you like, you can always sponge off some of the blue where the flowers are to go. **Fig. 77** shows another way of adding flowers: the buttercups and daisies have been painted in below the skyline and grasses filled in between them.

Fig. 78 also shows flowers in a landscape – a sea of bluebells in a mixture of Cobalt Blue and Cobalt Violet; one plant of Wood Sorrel, which was painted first of all, has been given a more detailed finish to make it stand out from the background and dominate the scene.

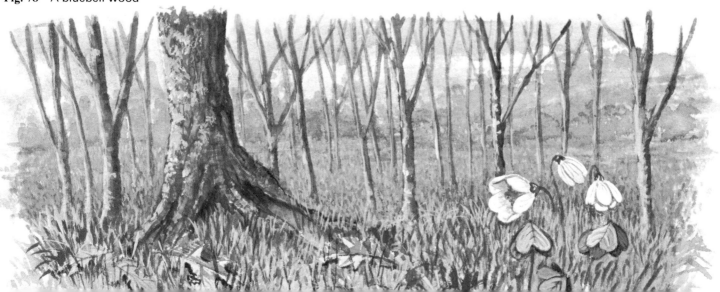

The paintings in **figs. 79 and 80** illustrate quite a different approach to the subject of flowers painted within a landscape. There is hardly any sky or distant view included. These Japanese Water Irises grow beside our pond, and their lovely flowers are as large as soup plates.

First stage I wanted the irises to stand out as the main subject in the picture, witnout any other flowers to distract the attention. Because they are pale and delicately coloured I painted them first of all, without touching any background, and in quite a lot of detail in order to establish the correct balance of colour and depth of tone (**fig. 79**). This required a certain amount of painting in my mind's eye. I had a firm pre-formed idea in my head of just how I wanted the final picture to look. I used a mixture of Cobalt Blue and Cobalt Violet for the irises and various shades of green for the leaves, keeping both the flowers and the leaves fairly pale, so that they would stand out from the background.

Second stage Having established the correct tones of the flowers but before completing the details, I added the background. First of all I painted a small portrait of our favourite visitor, the kingfisher, who thinks the young trout who come up our stream and swim around the pond have been put there for his benefit. This lovely, exotic-looking bird visits us regularly but not always when I need him as a model, so this portrait was done partly from memory and partly from the quick sketches I have made in the past. I placed the bird in the top corner in order to balance the composition of the picture. I very often include some wildlife in my paintings of flowers, a bee or butterfly, a spider or a bird, for they are all part of the natural world of flowers and add interest to a painting. After all, there would be few plants if there were no bees to pollinate them. For this picture I also wanted to show three planes of diminishing importance, first the dominant and detailed irises in the immediate foreground, then the kingfisher on the branch on the other side of the pond, painted in less detail than the flowers in order to establish its position of secondary importance, and beyond this an indistinct mass of foliage to support but not engulf the two main subjects. The background has been painted fairly dry. A wet wash of colour was not possible on such a small picture – for I wanted it the same size as you see in **fig. 80** – so I used the technique of the miniaturist and stippled in my dark colours to avoid spoiling the crisp outlines of the plants. In a painting such as this but on a large scale the background can be painted more wet. However, there is not always room in one's home for more than a few large paintings, and thumbnail sketches of the garden, or views of a holiday, can be more easily accommodated and are great fun to do. Although most art teachers urge one to produce big and bold paintings, there is

Fig. 79 Japanese Water Irises, first stage

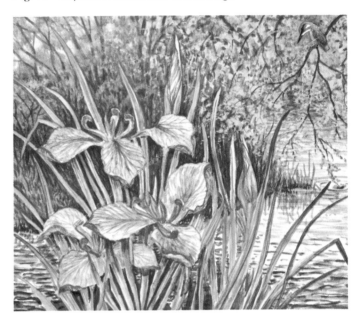

Fig. 80 Japanese Water Irises, finished painting

also a place for the small and beautiful.

In **figs. 81, 82 and 83** I have illustrated three stages of painting a gentian from sketches I did in the Pyrenees. A blend of French Ultramarine and Cobalt Blue is not only good for summer skies, in more concentrated tones it is also suitable for gentians; leave some soft highlights, though, or the flowers will look too heavy.

First stage I lightly drew the outline of the plant and sketched in the mountains. Then I painted the sky and the first faint washes of different greens for the trees and the meadows. At this stage I did not paint over the gentian plant at all. I also left small patches of clear paper here and there for the paler meadow flowers to be added later.

Second stage I deepened the colours generally and painted in the pale flowers. Then I painted one of the gentian flowers, to check the balance of colour.

Third stage Finally I painted the gentians in full detail, and so another souvenir of our visit to the mountains was ready to bring home.

Fig. 81 Gentian, first stage

Fig. 82 Gentian, second stage

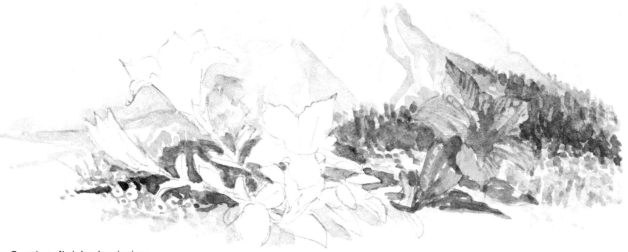

Fig. 83 Gentian, finished painting

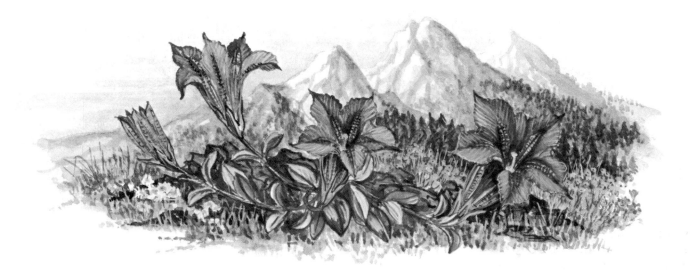

KEEPING IT SIMPLE

In order to show you as many varieties of plants as I can within one book, I have added more flowers to some of my bunches than I would normally do. However, I passionately love the simple, clean lines of the more strictly botanical style of flower painting with its uncluttered spaces, and if you too find the simple approach more to your liking, and prefer one flower to a dozen, then do not feel you have to change, for there is a place for all types of flower painting.

I make no apology for introducing yet another species of the poppy family here (**figs. 84 and 85**), for poppies make excellent models for beginners as well as for more experienced painters. This one is the Welsh Poppy. Like its relation the Common Poppy it has four petals of simple outline, but an important difference to note is the stalked top to the seedpod, which identifies it as a member of the Meconopsis group – another member is the Himalayan Blue Poppy so beloved of gardeners. The colours of the Welsh Poppy are sharp and clear and must remain so, and although greenish shading is essential to create a feeling of roundness to the crumpled petals, be careful not to overdo it. Keep some areas clean Lemon Yellow with a touch of Cadmium Yellow.

The simple approach is not always simple when it comes to painting, for you cannot hide anything behind another flower, and the composition is all-important if you are to achieve a pleasing and living portrait of one species from the bud right through to the ripe seedpod.

Fig. 84 Sketches of Welsh Poppies

Fig. 85 Welsh Poppies, finished painting

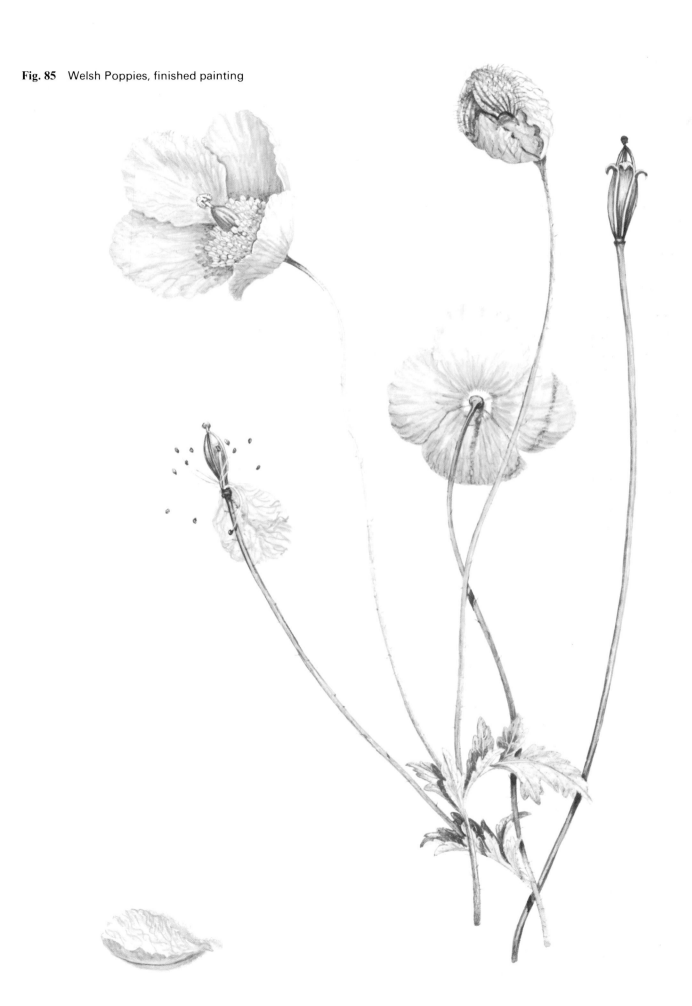

PHOTOGRAPHY AND THE FLOWER PAINTER

Photographing and painting flowers are two completely separate arts which, in my case, run parallel to each other and only occasionally combine. For a variety of reasons, I prefer not to paint flowers from photographs. We photograph the flowers because we enjoy doing it, and the resulting slides form an important part of the talks we give. They are also a quick method of recording certain facts and I later refer to them for specific information, such as the type of plants among which a particular flower is growing, or the height of a plant, which can easily be judged by comparing it to the surrounding vegetation or to some other familiar object, as in the case of the thistles in Bavaria (**fig. 88**), when I acted as the yardstick. In the other photograph on this page (**fig. 86**) I am sketching a plant of Alpine Lady's Mantle in the Pyrenees; this photograph is useful only in so far as it shows the compact form of the plant, and how it grows out of bare rock. It is vital for me to add a fairly detailed sketch of the whole plant, accompanied by notes, and collect a leaf or two to paint later to show the pale, serrated edges and the contrasting colours and different textures of the two sides of the leaves (**fig. 87**).

Fig. 86　Sketching a plant of Alpine Lady's Mantle, in the Pyrenees

Fig. 87　Leaves of Alpine Lady's Mantle

Fig. 88　Standing among giant thistles, in Bavaria

The two main reasons why I will not rely on photographs for more than a passing reference are, first, because the single eye of the camera will only show you a flat flower portrait, all on one plane. The only way, at present, of getting a three-dimensional look is to throw everything beyond the chosen flower out of focus, or in deep shade. The result is effective and often attractive, but hardly helps the painter to get the necessary details of the back view of the florets showing through from the other side of the spike. Nor can one gauge the feel of a plant, how soft the hairs are on the stem, or how velvety the leaves. It is so important actually to handle the plant and look at it from all angles. Secondly, even the very best slides do not always give quite perfect colour rendering; mauves and blues are particularly vulnerable and vary considerably from accuracy. The photographs on this page show Lizard Orchids in France. **Fig. 89** shows a Lizard Orchid growing among the sand dunes (again I am acting as the indicator of its height). **Fig. 91** shows a plant in a woodland habitat; and **fig. 92** is a closer shot of the same plant. The painting in **fig. 90** shows details of Lizard flowers at different stages of development. The Lizard Orchid is strange, and a rare plant in Britain. It would be a crime to pick it, and in this case photographs, together with the painting of the florets, helped me later to paint the whole plant for a book. A complete drawing done on the spot would take a very long time, for there can be as many as two hundred flowers on each spike.

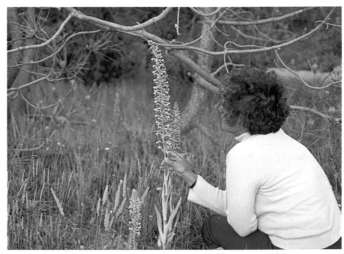

Fig. 89 A Lizard Orchid growing among sand dunes

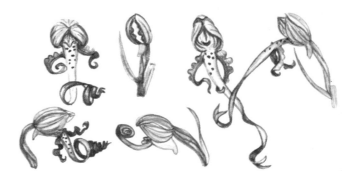

Fig. 90 Lizard Orchid flowers at different stages of development

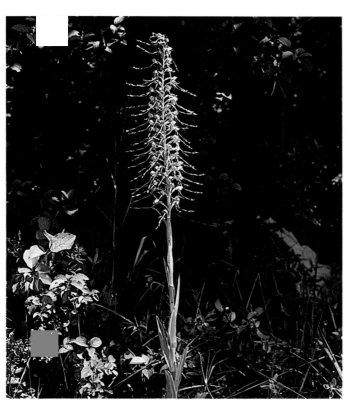

Fig. 91 A Lizard Orchid in woodland

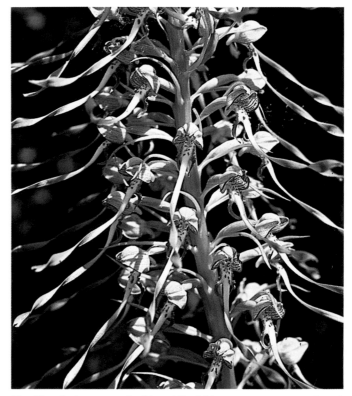

Fig. 92 A close-up of a Lizard Orchid

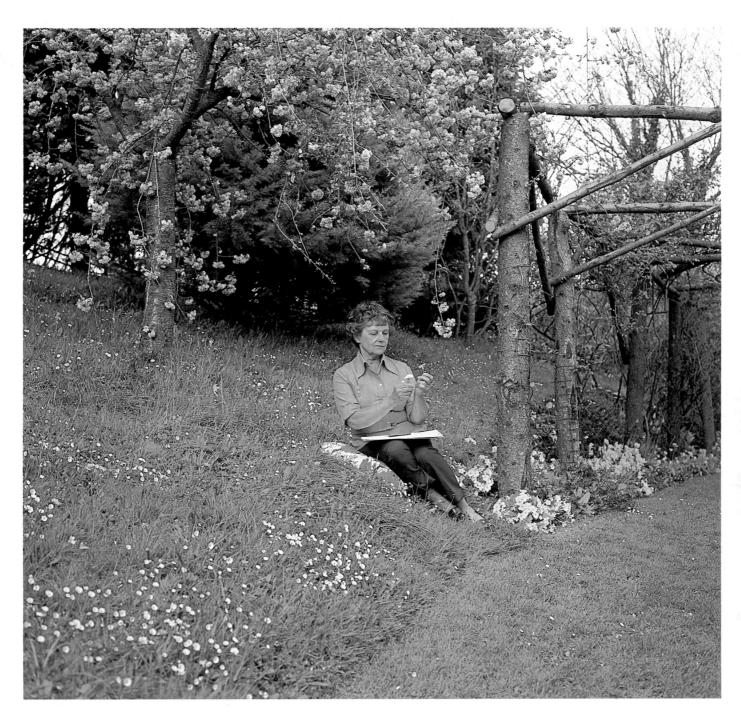

I hope that through this book I have been able to encourage many of you to start painting, however long ago it was that you last held a brush – or even if you have never held one. I hope too that you will try painting the flowers of our gardens and countryside. Remember what I wrote near the beginning of this book. If you practise, you can only improve. If you are not satisfied with your portrayal of a particular flower, then find an easier one and start again, and before long you will discover as I did that the first flower is not too difficult after all. Immense pleasure and satisfaction can be found among the flowers of the field, so paint them and enjoy yourselves.